A LONG WALK
ON THE ISLE OF SKYE

DAVID PATERSON

PEAK PUBLISHING LTD.

© Peak Publishing Ltd., 1999
© Photographs and text: David Paterson, 1999
None of the photographs in this book has been
computer-enhanced or altered in any way.

First published in Great Britain by:
Peak Publishing Ltd.,
88 Cavendish Road,
London SW12 0DF.

ISBN 0 9521908 4 2
Cataloguing in British Library publication data applied for.

Paterson, David
A Long Walk on the Isle of Skye
1. Travel (GB)
2. Photography

Other titles in series with this volume:
Heart of the Himalaya – Travels in Deepest Nepal (ISBN 0 9521908 2 6)
The Cape Wrath Trail – A 200-Mile Walk Thro' the NW Highlands (ISBN 0 9521908 1 8)
London – City on a River (ISBN 0 9521908 3 4)

Cover photograph: Tarskavaig and the Cuillins

Designed by Peak Publishing
Maps by Jim Lewis
Typeset in Opus 11/14
Originated & printed by:
C&C Offset Printing Co. Ltd., Hong Kong

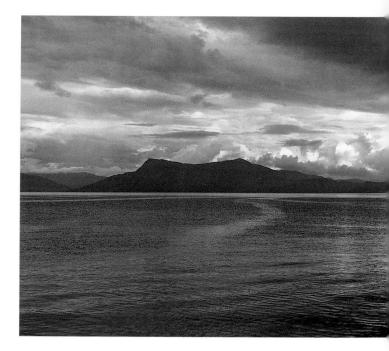

CONTENTS

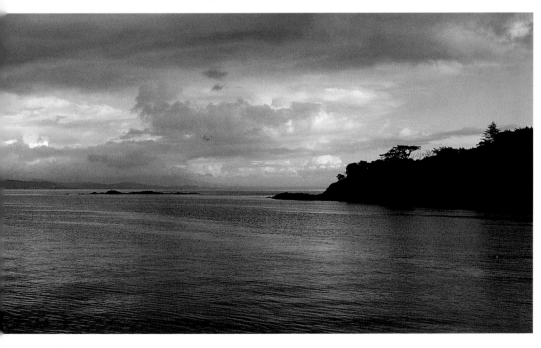

*The Sound of Sleat, looking
south from Armadale Pier*

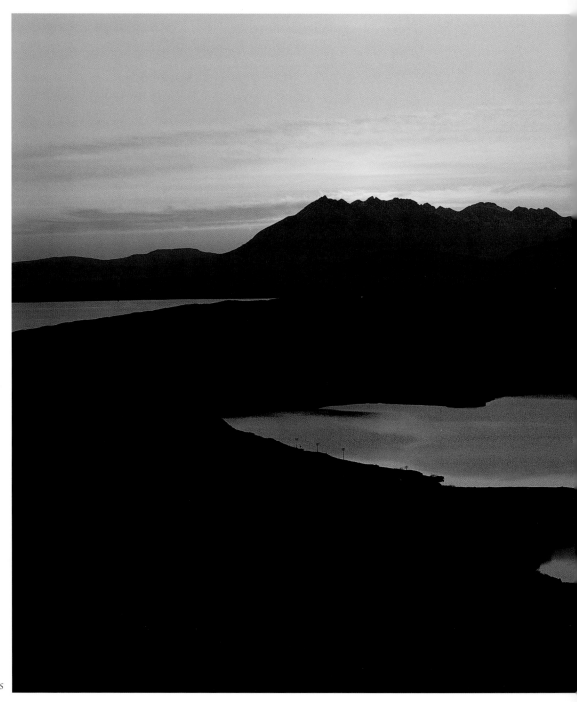

Loch Dhughaill and the Cuillins

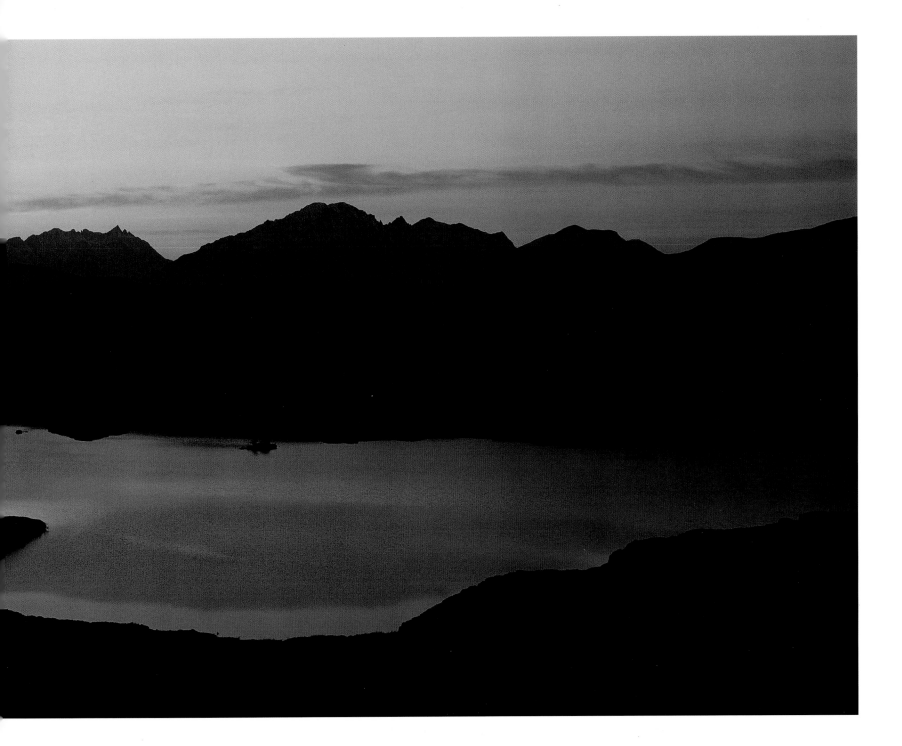

PREFACE

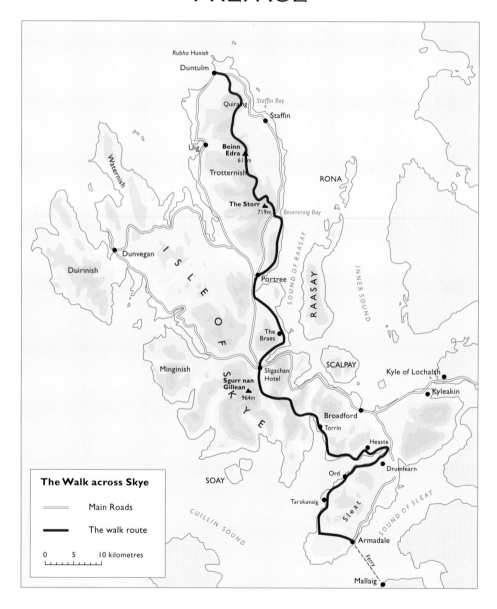

The Walk across Skye

— Main Roads

— The walk route

0 5 10 kilometres

Rubha Hunish
Duntulm
Quiraing Staffin Bay
 Staffin
Uig Beinn
 Edra
 611m
Trotternish RONA
The Storr
719m Bearreraig Bay

Waternish

Dunvegan SOUND OF RAASAY

ISLE RAASAY INNER SOUND

Duirinish OF

 Portree

 SKYE

Minginish The
 Braes SCALPAY
 Sligachan
 Hotel Kyle of Lochalsh
Sgurr nan
Gillean Kyleakin
964m

 Broadford
 Torrin
 Heaste
SOAY
 Ord Drumfearn

Tarskavaig Sleat SOUND OF SLEAT

CUILLIN SOUND Armadale
 Ferry

Mallaig

THE ROUTE RUNS FROM ARMADALE, in southern Sleat, across to the north coast of the peninsula. It goes around Lochs Eishort and Slapin, through the north-east fringes of the Cuillins, and via Glen Sligachan – between Marsco and Sgurr nan Gillean – to the Sligachan Hotel. It then takes the east coast through The Braes and Portree to The Storr. The last two days follow the Trotternish Ridge from The Storr to the Quirang, finishing over Sgurr Mor and across the moors to Duntulm.

I tried to devise a route which runs logically from south to north, making detours only when forced by the terrain. It samples the scenery of the west and east coasts of the island, and enjoys some of the superb mountains of Skye without ever posing difficulties other than those of route-finding. Every day of the walk (bar one) ends where accommodation can be obtained in the vicinity.

Valtos, Trotternish

I spent the winter of '97/98 planning the route, and looking at and walking long stretches of it. I wanted the book to show all the seasons, and I knew from long experience that it would take many months and many visits before I had enough photographs to make a book. In the end I spent around ten days a month on Skye for twelve out of thirteen months. For most of that time it rained. I walked the whole route from south to north in May 1998, and from north to south later in the summer. At other times I walked sections of the route to try out alternatives and to work on the photography, which was only completed in November '98.

The maps which introduce the chapters each show two days' walking. They should NOT be used as guides for actually doing the route. The required maps are the Ordnance Survey 1:50,000 Landranger series, numbers 32 (South Skye) and 23 (North Skye), and the route should not be attempted without these maps. Ideally, previous experience of long-distance walking is desirable, as some sections of this walk lack an established path, and map and compass-work, and some route-finding abilities, may be required.

When I started the project I thought I knew Skye fairly well, but doing the work for the book not only taught me a good deal about the island, but re-awakened a great affection for it and its people. There are sights and places, and experiences I had in the doing of it, which I shall always treasure, and I have indulged this love of Skye in a long introductory chapter, which is a review of the island and its glorious landscapes.

EILEAN A' CHEO

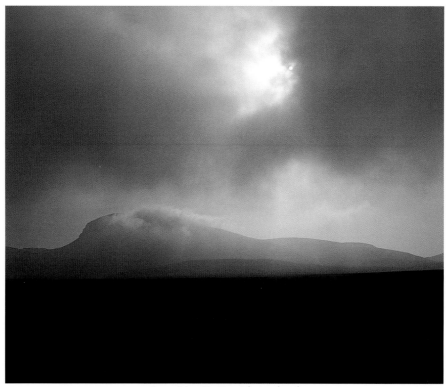

Sgurr Mor, Trotternish, in cloud

Picture an island. Small enough to *feel* like an island, but big enough to prolong the joys of exploration; an island with a coastline of steep cliffs, blunt headlands, deep fjords and occasional gentle bays; enough farmland to support a decent sprinkling of people; and with a rugged, mountainous heart. Since our island is remote from sources of atmospheric pollution the air is clean, and especially on a fine day in late autumn or winter there is a crispness and clarity which lends everything an almost transcendental beauty. Its climate is mild, thanks to warm oceanic winds and currents which sweep in from the west. On many days in the year, however, these moisture-laden westerlies cloak the high ground with clinging mists and vapours; sightlines veer, mountains blur, fade and dissolve, and the crags are veiled by shifting streamers.

There is a mythic quality to the landscape. Mountains erupt from valleys in vast exposures of naked rock, gaunt ridges, or rounded stumps of red granite. All around the coast long arms of the sea reach deep into the interior so that the traveller is constantly surprised by great expanses of salt water where only land should be. The island's origins are volcanic, and through the ages it has been torn by earthquake and upheaval, drowned in lava, planed by glaciers, splintered by frost and smoothed by water. Plateaus shear into jagged scarps and pinnacles, and narrow, shattered ridges swing from peak to peak; sea-cliffs tower like battlements, and black skerries patrol the shores like submarine wolfpacks in the endless surge and slide of the sea. Not all is

drama and spectacle, however, and the island also has a gentler face. Scattered townships nestle in the lee of soft hills, and farms are tucked away in quiet valleys. At either end of the island, the ferries which connect it with the world slip in and out of sheltered harbours. Here and there a village punctuates the endless vistas of mountain, sea and sky, and the one small town bustles with friendly life.

All this might sound like the scenario for another Tolkeinesque novel, but perhaps most will recognise an only slightly-romanticised version of a well-loved island. The Vikings who came here more than a thousand years ago called it Skuyo, Island of Cloud, and long ago its own Gaelic poets named it Eilean a' Cheo, The Island of the Mist.

Very little encouragement is needed to paint a romantic picture. Its complex geology has given Skye a unique landscape, both subtle and dramatic, and its turbulent history has ensured the island's worldwide fame. From the end of the Viking era seven hundred years ago, Skye's two great houses, the MacDonalds of Sleat and the MacLeods of Dunvegan, fought each other down the long centuries for dominance on the island and throughout the Hebrides, in a maelstrom of blood, cruelty and sometimes heroic sacrifice. But the single episode which perhaps did most to boost Skye's fame was the flight of Prince Charles Edward Stuart after the 1745 rebellion, a story which has long since passed into enduring legend, greatly to the benefit of the island's modern tourist industry.

From the late 18th century, for more than a hun-

dred and fifty years, the island's history speaks only of emigration and depopulation. In the aftermath of the '45 the revered clan-chiefs of the Highlands began their swift fall to the position of mere land-lords, and tormentors of their people. That baleful saga of eviction and banishment which is known as "The Clearances" had begun, and when it ended the Scottish Highlands had a diaspora almost to rival Israel's. Though some of the first waves of emigration from Skye might be desribed as volun-tary, their root cause was identical with those of the many forced migrations which followed very soon after – the greedy and grandiose lifestyles of their now estranged chieftains.

Where a man had paid for his tenure of the land with labour and loyalty, or in time of war with ser-vice, his clan-chief now demanded money. Rents were introduced and were quickly racked to levels which the people could not possibly afford, in an economy which had little use for cash and few ways to earn any. Clan lands, once held in trust by the chiefs on behalf of their people, had by some sleight-of-hand become the private property of the aristocratic families, and to many of the common folk emigration to the distant colonies of the New World began to seem the only escape from a sys-tem which now kept them in virtual slavery. By the end of the 18th century, the new "estates" were already being parcelled up and let out, or sold off, to sheep-farmers from the south who only wanted rid of the highlanders who clung to their native glens and straths. Whole populations were cleared

from their ancestral lands to barren and unproduc-tive coasts, to the slums of Glasgow, or to distant Canada, USA or Australasia. This policy (they called it "Improvement") was pursued with the greatest vigour and enthusiasm throughout the 19th century by the landlord class, whose instructions were fre-quently carried out with maximum callousness and cruelty. With the introduction of the idea of sport-ing estates, the process was taken further. Much of the land was returned to a form of wilderness with-out people, and even without sheep, where wildlife could be left to flourish unhindered, to be slaugh-tered on a seasonal basis by rich southern visitors who would pay handsomely for the privilege.

The population of Skye fell from a peak of over 23,000 in the 1840s to 14,000 at the turn of the cen-tury, and had declined to less than 8,000 by the mid -1960s. Since then there has been a recovery, and today the island is one of the fastest-growing areas of the Highlands, its population boosted not only by newcomers from around the British Isles but by returning islanders and the descendants of islanders. There is a new and palpable confidence on Skye, and developments and revivals of all kinds are afoot, not least a rekindling of interest in the Gaelic language, which like most aspects of the native cul-ture had long been in decline. The big new bridge across the narrows at Kyle, not as ugly as many feared (and resisted only by those who did not truly have the interests of Skye at heart), may have removed some of the charm from the crossing but can only improve communications and bring new

life to the island (in spite of the punitively high tolls, justifiably resisted by many of the locals who won realistic rebates for bona-fide Skye-dwellers).

The landforms of Skye are more varied and spectacular than one small island has any right to, and were the foundation and laboratory for many of the most fundamental geological theories, which were first formulated here. The rocks exhibit all the classic formations of lifting, tilting, folding, fault formation, metamorphism, sedimentation and volcanism, in addition to the results of more recent glaciation and erosion, and these effects are clearly visible. The oldest rocks are Lewisian gneisses some 2,800 million years old which were brought to the surface by intense folding and form the low, rolling hills of the Sleat peninsula in southern Skye.

Further north, the coasts of the island are deeply indented by sea-lochs formed where large glaciers melted and their trenches were filled by a rising sea-level. Lochs Eishort, Slapin and Scavaig on the west coast and Ainort and Sligachan on the east are prototypical fjords – long, narrow arms of deep, dark water penetrating far inland, flanked by mountains rising directly from the shoreline. The western fjords are overlooked by the Black Cuillin, whose slender ridges of shattered gabbro sway like tight-ropes from peak to jagged peak, and on the east coast, the Red Hills are rounded but still steep humps of pink and grey granite in a near-terminal state of erosion. Both mountain ranges, though very different in character, are the roots of long-dead volcanoes, solidified magma chambers originally deep underground but exposed through the ages by the actions of water, wind and ice. Both show the effects of Skye's most recent glacial period, only 10,000 years or so ago, when a new ice-cap sculpted their corries and honed the ridges of the Black Cuillin to the shapes we are familiar with today.

The Cuillin, almost without argument, is the most exciting mountain range in these British Isles. From Gars-bheinn above the shores of Loch Scavaig the ridge of twenty-some peaks swings in a sublime arc twelve kilometers long around Coruisk (Cor'uisg, The Corrie of Water), all the way north to Sgurr nan Gillean, whose Pinnacle Ridge looms over the Sligachan Hotel, the historic climbing-base for all early exploration and ascents in the Cuillin. Across the great gulf of Glen Sligachan, the separate but no less impressive Bla Bheinn/Clach Glas group almost completes the circle of peaks. Altogether, twenty-two individual tops reach the magic figure of 3000 feet (914m), and twelve are classified as Monros. The highest of all is Sgurr Alasdair, which reaches 3250 feet (993m).

It is not the height of these mountains, however, which gives them their special character. Deeply scoured by repeated glaciation, the corrie-walls are steep and the ridges linking the summits are often dizzyingly narrow. The rock architecture is spectacular, with finely-chiselled ribs, buttresses, ridges, gullies and walls of compact black rock – rough gabbro and smooth basalt – whose colour emphasises the stern atmosphere. Above the lowest slopes the rock is bare of all earth and vegetation,

the mountains are stark and severe, and the summits can be sharp enough, like Sgurr Alasdair or Sgurr nan Gillean, to permit just one person at a time to stand on the topmost rocks. Few of these summits can be reached without some knowledge of basic rock-climbing.

The scenery everywhere is glorious, the southern tops giving wide panoramas over Loch Scavaig, Soay Sound and the island of Soay, with Rum basking on the western horizon. The central summits look straight across Loch Coruisk to Clach Glas and Bla Bheinn, and the northern peaks are close to Marsco and the Red Hills with more rolling hills and huge tracts of moorland to the north and east.

In modern times, the centre of climbing activity has moved from Sligachan to Glen Brittle. A couple of decades ago, though the campsite there might have been busy in the summer months, the peaks and ridges were less so, and an expedition along the main ridge or round a corrie-rim could often result in an entirely solitary day. It is different now. In high season the site will be crammed, and where many people were once content simply to look or dabble at the margins, today's campers are likely to be serious walkers and climbers, and most routes will be very popular. But come in late autumn or winter (always the best season to sample the true atmosphere of the Scottish mountains) and savour the Cuillin at its finest. That combination – a dusting of fresh snow on the summits beneath an azure sky, the glens touched with brown and gold, and a low sun dipping towards

the hills of Rum – is hard to beat and, sitting here now, just the thought brings an ache of longing.

Because there is rarely any great build-up of ice in the Cuillin, it never became a Mecca for winter-climbing like Glencoe or the Cairngorms so there is every chance that, on your chosen route, your party will be the only one. (Though I don't think of myself as unsociable, in the hills I do try to avoid people. It has always seemed to me that a certain amount of solitude is necessary for any real appreciation of what the hills have to offer. If there is a queue to be joined at the foot of a rock-climb, or the start of a ridge-walk, the expedition is more than half-spoiled before it has properly begun.)

We think of the mountains, and indeed all wild landscapes, as eternal, and certainly the Cuillin seems so – immutable, everlasting and beyond the power of mere humans to change to any significant extent. But many of the landscapes we take for granted have come into being in recent geological or even historical times, and because of man's direct intervention – for example the de-forestation of northern Scotland (including large tracts of Skye) whose empty 'wilderness' and blanket peat-bogs seem entirely natural to us today. Looked at from a distance, there is probably little that can alter the profile of these mountains; close to, however, much change is already clearly visible, due simply to the passage of many feet. Popular access and descent routes are wide erosion channels, former scree-runs are bare earth or rock with all the scree in a great pile at the foot, and though the use of

pitons is probably rare in the Cuillin nowadays, there is nevertheless hardly a route which does not show the scars of hardware, from the tricouni nails of the pioneers through the scrapes of crampons and ice-axes to damage caused by pitons, nuts and even bolts. How do we preserve the mountains we love, and yet have the freedom to be among them, to climb and wander at will? Such questions should increasingly concern us all, these days, as we take to the hills in ever-greater numbers. (But Heaven help the Cuillin should industry ever discover a large-scale use for gabbro or basalt!

A long time ago, a complete winter traverse of the main ridge was my greatest climbing ambition, and in February 1978 I came with my climbing-partner for our second attempt at the traverse. We believed it had only been completed once before (by a very famous team) and we had waited a long time for the perfect conditions, with friends on the island primed to phone when the hills had a good plastering of snow. When the call came we headed north, post-haste, and the next morning, looking across the narrows from the slipway at Kyle of Lochalsh, Skye was white almost to the waterline.

The previous winter three of us had started from Sligachan and gained the main ridge via Sgurr nan Gillean at the start of an unsuccessful attempt. This time we set off from Glen Brittle on the long walk to the foot of Gars-bheinn at the southern end of the ridge, and a long climb to this, our first summit. The weather was spectacularly good and the forecast promised a stable high-pressure area to last several days, the ridge was thickly covered, and the snow seemed to be in excellent condition. As for us – we were strong and eager and it seemed as if nothing could stop us this time. Nevertheless, only 48 hours later we were on our way off the mountains, beaten again. Though most of the ridge was straightforward, every verticality, under a covering of wind-blown powder-snow was smeared with verglas, the climber's greatest enemy. Iron-hard ice just a millimeter or two thick, created by melting and re-freezing – verglas oozes over the rocks like treacle and adheres so strongly it cannot be smashed off with ice-climbing tools. With the minimum of equipment we were carrying, and with the limited time at our disposal (three days for the whole ridge) we had been unable to climb the three major difficulties which are concentrated in the Gars-bheinn half of the ridge. After repeated attempts and failures we had finally bypassed the Thearlaich-Dubh Gap and King's Chimney, and quit on the Inaccessible Pinnacle, and even if we completed the rest of the traverse in impeccable style we could not claim a second ascent.

It was the afternoon of our second day on the ridge, and as we had toiled and failed the day had sped away. We gathered and repacked our gear and ran off downhill towards Glen Brittle, into the gloaming. The following winter other parties made successful second and repeat traverses of the ridge before we got our act together; we never returned to Skye together as a climbing team.

Later I often regretted abandoning the climb,

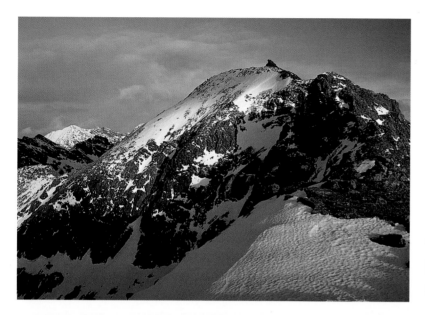

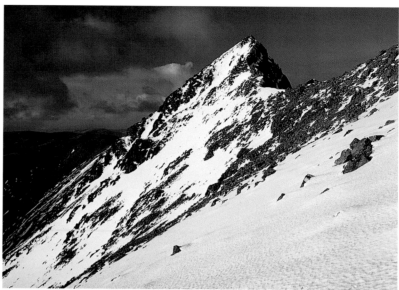

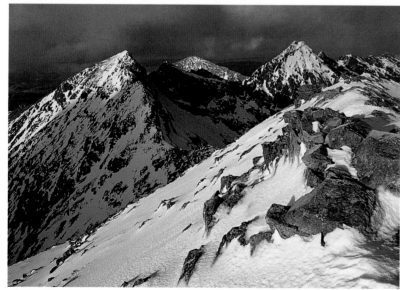

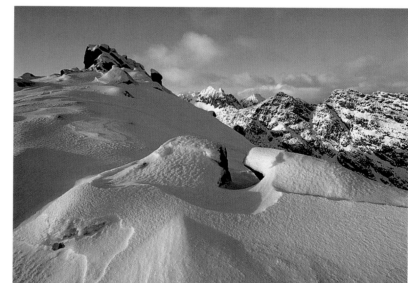

The Cuillins in winter

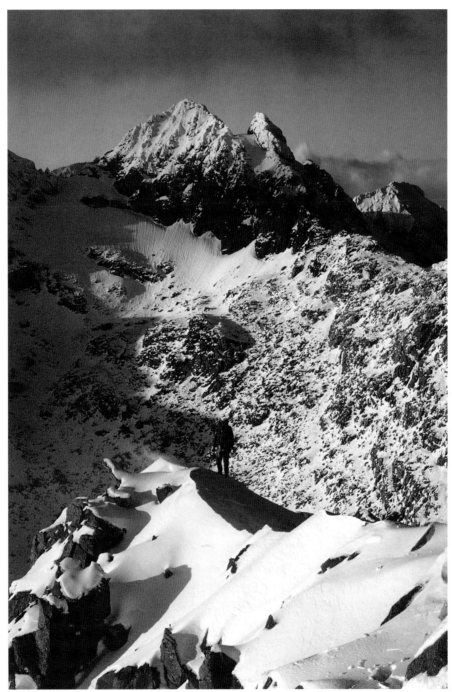

Sgurr Alasdair across Coire a' Ghrunnda

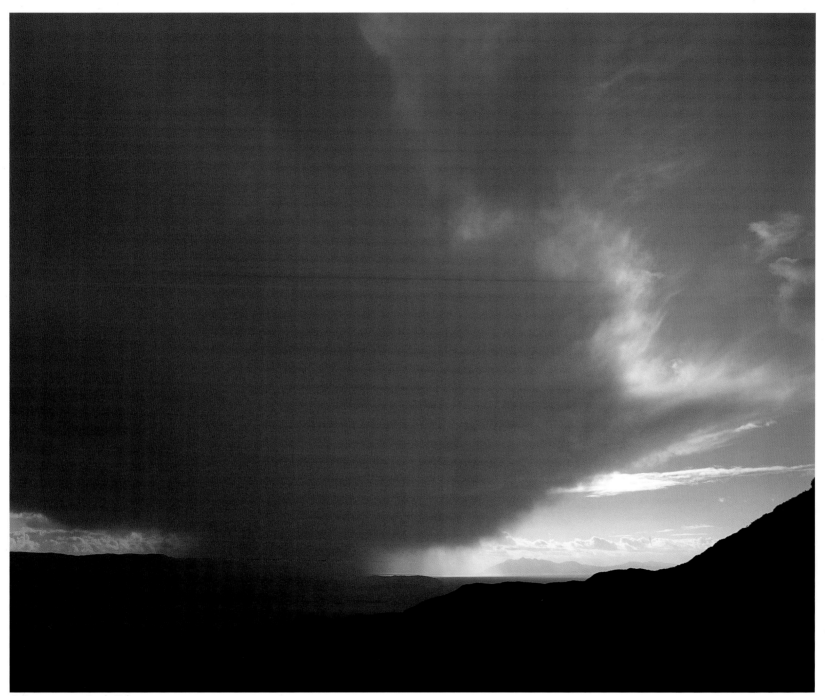

Rainstorm over Loch Eishort

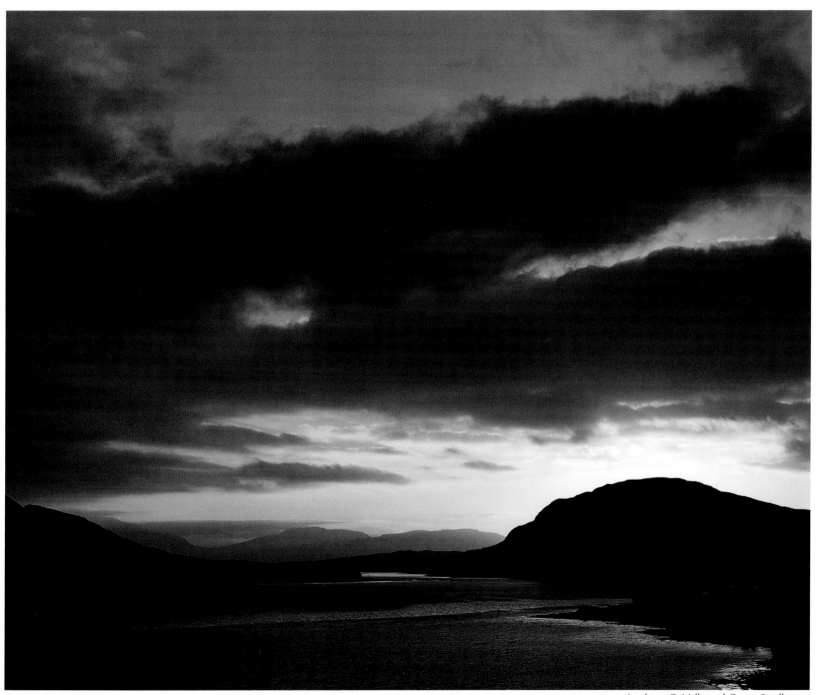

Loch na Cairidh and Creag Strollamus

every moment of which had been memorable right up to the point where we quit. Youthful ambition had been thwarted and if we couldn't claim the full second ascent there seemed no point in continuing. From a longer perspective, of course, it is clear that there was every point in finishing out the ridge, not least the pure pleasure of just being in the mountains in such superb conditions. I would not make a similar mistake now, but though I have been back to the Cuillin many times since, I have never again enjoyed such ideal circumstances.

North of the main band of mountains Skye consists of an undulating lava plateau – the outpouring of the volcanoes whose cores formed the mountains themselves – bounded by a coastline of cliffs and high, rocky headlands. Though the interior is less mountainous than that of the southern half of the island, the coast is seldom less than spectacular, and as well as tall cliffs there are many inshore islands, singly and in groups, which enhance the beauty and atmosphere of the scene. From the least eminence there are vast oceanic views under soaring skies, with the Outer Hebrides (or from the east coast of Trotternish, the mainland of Scotland) filling the horizon. The north coast is divided by broad sea-lochs into three great 'wings' – Duirinish, Waternish and Trotternish – of which Waternish, in the centre, is (to me, at any rate) the terra incognita of Skye, penetrated only by a single narrow road as far as the foot of its low, northern hills – Halista, Geary and Ghobhainn. Everyone streams west, to where the celebrated but ugly Dunvegan Castle

stands at the gate of Duirinish below the unmistakable profiles of MacLeod's Tables – Healaval Mor and Healaval Beg – massive flat-topped hills which are all that remains of eroded lava-flows. Beyond them, most of southern and western Duirinish is a wilderness of sharp little hills and blanket bog, with a wild, lonely coast of high cliffs decorated by natural rock arches and occasional waterfalls.

The third and eastern wing, Trotternish, is the pearl of the three for its superb central escarpment – easily the most impressive mountain feature on Skye after the Cuillin. This the nonpareil of what geologists call 'trap' landscapes. During the island's volcanic era, vast flows of lava spread horizontally between existing layers of sedimentary rock; later, the whole land-mass tilted sharply to the west. At the eastern limit of the flows where most lifting occurred, the great weight of the basalt caused weaker rocks below to give way in successive landslips of enormous proportions. The result of all this is a continuous line of cliffs and summits stretching more than twenty sinuous miles from just north of Portree almost to the northern tip of the peninsula. The two most outstanding features are The Storr near the southern end of the ridge, and its twin The Quirang at its northern end. Like all the hills of Trotternish, their western slopes descend gently in long grassy swales towards the distant coast, but their steeper eastern slopes are crowned by high vertical cliffs seamed with gullies and attended by an extravagant array of stacks, pinnacles and buttresses. It is hard to say which is the more fantastic,

but the Quirang might just get my vote. Its series of perfect grassy alps, each a little smaller than a football pitch and each on a sharply-raised plateau, all contained within a sunken corrie just below the summit of the mountain and surrounded by steep cliffs and serrated ridges, is unique.

Beyond the Quirang, the main line of cliffs continues in amazing fashion past the terraced peak of Leac Fionn (Finn's Gravestone) to a final dramatic gesture at Sron Vourlinn. A second line of cliffs, slightly to the west, supports the great flattened dome of Sgurr Mhor, the final summit of the Trotternish ridge, whose northern slopes merge into a rolling moor which stretches away to the furthest tip of Skye, Rubha Hunish. The view to the north-west from Sgurr Mhor is an immensity of sea and sky with the Outer Hebrides, hinting at further mysteries, lying darkly along the far horizon.

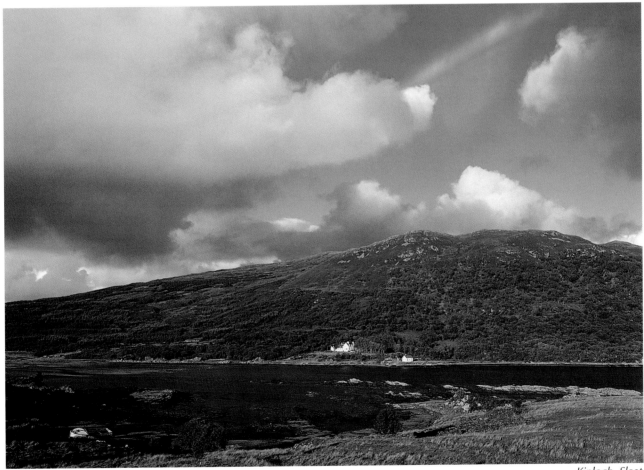

Kinloch, Sleat

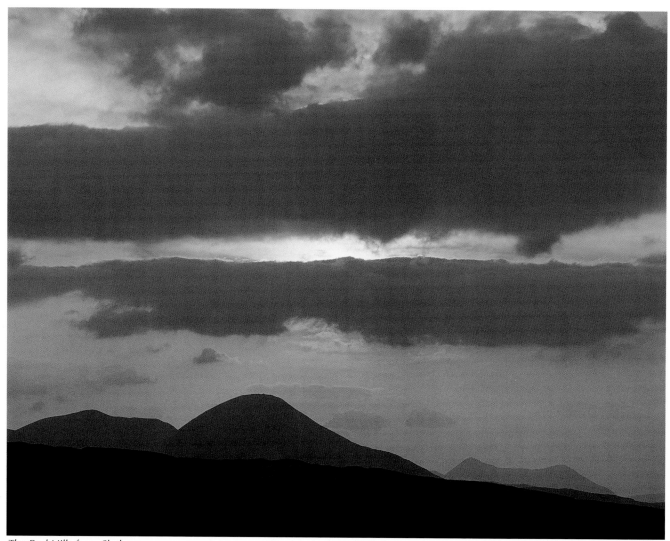

The Red Hills from Skulamus

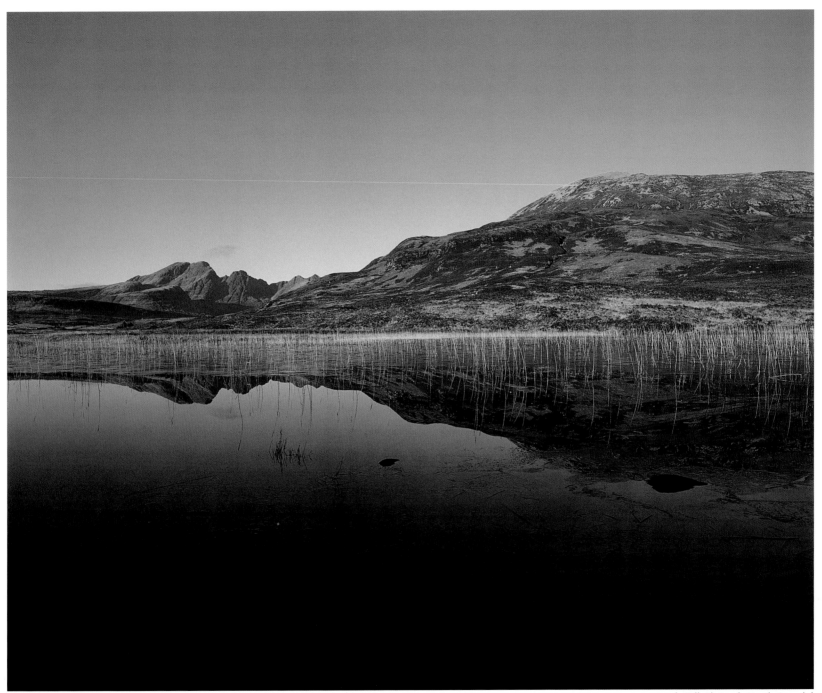

Loch Cill Chriosd, Strath Suardal

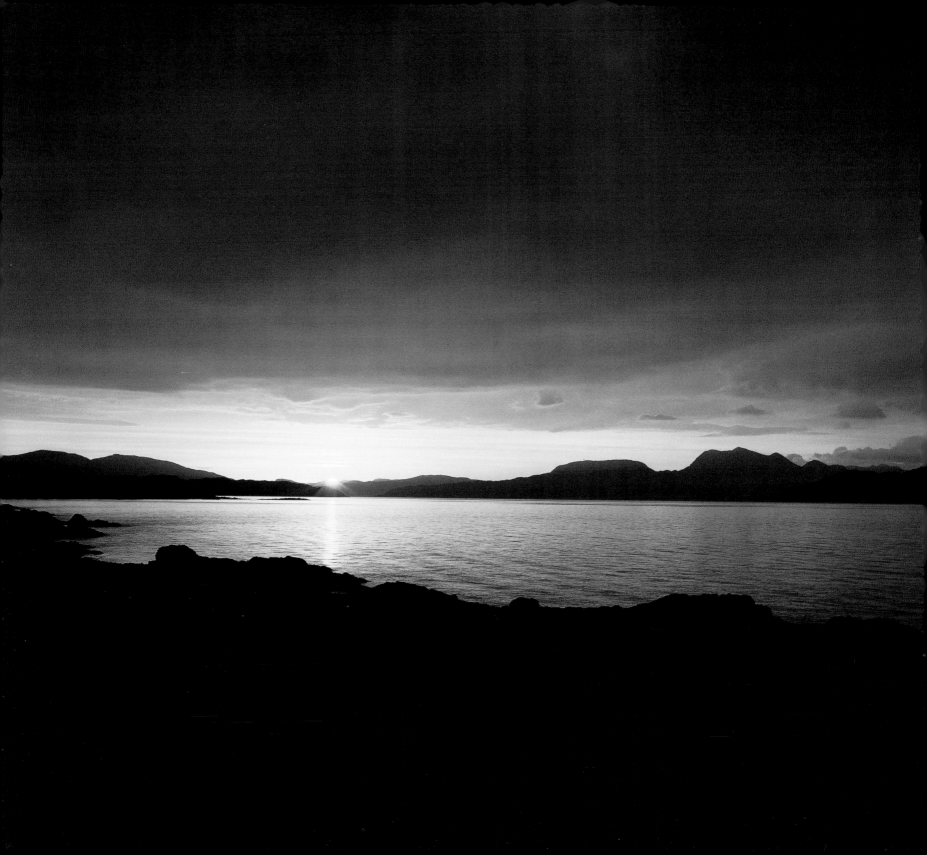

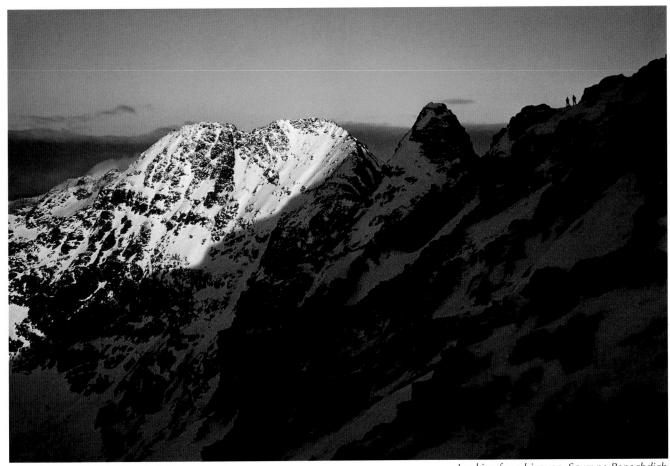

Looking for a bivouac, Sgurr na Banachdich

Sound of Sleat at Armadale

DAYS 1/2 ARMADALE - HEASTE

Heaste

Suisnish Boreraig

Drumfearn

LOCH SLAPIN

LOCH EISHORT

Morsaig

Ord

Castle

Tokavaig

S L E A T

Tarskavaig

Gillean Achnacloich

SOUND OF SLEAT

Coille Dalavil

Loch á
Ghlinne

Caradal

Cnoc an
Sgùmain

Armadale

Ardvasar

Ferry to Mallaig

0 1 2 3 4 5 kilometres

Point of Sleat

DAY ONE, AM. ARMADALE PIER TO DALAVIL (8.5kms, 1/2 day, height-gain 230m). Follow the road out of the carpark at the pier, and take a left fork signposted Ardvasar. Walk through the village past the shop and post-office, and turn right at the old police-station, going steeply uphill for two hundred meters to fork left through a gate beside a bungalow. Follow the track through another gate onto the open hillside. Continue up open slopes towards the skyline to the north, heading for a bealach between two low rounded hills. Climb the easy hill (Cnoc an Sgumain) above the bealach, from where another, lower ridge becomes visible with Loch a' Ghlinne beyond in the valley-bottom. Descend to the second ridge, heading for a prominent rounded knoll, and from there descend into the lower glen, crossing the stream (Abhainn a' Ghlinne Mheadhonaich) easily at one of many shallows half-a-kilometer or so to the west of the ford marked on the OS map. (DO NOT stay on the south side of Loch a' Ghlinne, as below the loch the river becomes much more difficult, even dangerous, to cross.) Follow a track past ruined croft-houses and through the woods on the north shore of the loch to the lone tin-roofed cottage named Dalavil on the OS map.

Ruin at Dalavil

DAY ONE, PM. DALAVIL TO ORD (10.5kms, long 1/2 day, height-gain 120m). The sketchy footpath peters out at the cottage; continue in the same general direction, slowly trending right and keeping close to the foot of the slopes on the right. It is possible to go down onto the beach about one kilometer past the cottage, but quite soon the shore has to be abandoned for the clifftop (easy access at several places) which is followed until the beach at Gillean comes in sight. Most of the way it is best to keep 100 meters or so back from the edge to avoid having to detour around the many deep coves, gullies and ravines which penetrate these cliffs. At Gillean join the road which is followed all the way to Ord, via Tarskavaig and Tokavaig. (Alternatively, it is possible to continue to follow the shore-line; however, this is longer and harder than taking to the quiet and pleasant road. Since much of the first three days' walking is coastal, the road, which runs for long stretches through fine mixed woodlands, gives a pleasant contrast.) Whichever route is taken, it is worth a few minutes' detour to visit the crumbling but fascinating ruins of Dunscaithe Castle at Tokavaig Point. B&B is available in both Tarskavaig and Ord in the summer months.

To arrive in southern Skye by ferry is still special. Islands do something to our minds (none more so than Skye) and on the crossing that familiar and pleasant feeling – of leaving the world behind – floods in. I am glad, for the sake of this book, that the Skye bridge could not be built here where the Sound of Sleat is almost eight kilometers wide, and that the bridge is out of sight and mind, halfway up the island at Kyleakin. I am hoping that some of those special feelings of nostalgia and anticipation will be bestowed on this trek, and arrival by ferry is very much a part of that because, quite literally, you step off the boat and begin walking.

Approached by sea, particularly during the spring and early summer, the east coast of Sleat is green and lush. Dark woods clothe all the lower slopes of the hills, and this part of the island has benefitted from the proximity of Armadale Castle, the ancient seat of Clan Donald (and a ruin since 1855), whose grounds were planted with many species of tree, not all native to Skye. In tall spruces just above the road near the turn for Ardvasar, a large and noisy heronry is the first intimation of Skye's prolific wildlife. On the short walk into the village, trees at first screen the sea but soon the shore is open to view, and in the shelter of rock skerries just offshore an armada of boats lies moored; boats are hauled up on the beach, and in the bay there are sailing-boats, work-boats, fishing-boats, derelict boats; the influence of the sea is pervasive and inescapable here.

On this first day of a new walk (a new adventure) I march eagerly into Ardvasar, to shop at the little store and get away up on to the hill as quickly as possible. Looking down over the village, the views are already expansive; the ferry is ploughing its way back to Mallaig across the wide blue gulf of the Sound of Sleat, beyond which, it seems, the entire Western Highlands are spread across the horizon. There is a path of sorts to be followed, and then a (geological) dyke, but it doesn't really matter; I just head for the skyline to the north and cross it at a minor hummock – Cnoc an Sgumain is slightly more prominent than some, and gives a good vantage from which to study the onward route. To the north-east a great sweep of undulating moorland is the interior of Sleat, crossed by roads at only two or three places and otherwise empty, a wilderness of sour heather moors, rock and lochan inhabited only by sheep, cattle and a few deer. The northern horizon is a long panorama of hills, with the jagged black silhouette of the Cuillin ridge occupying much of it. (In clear weather there is no day on this walk when these mountains, which dominate the whole island, will not be visible for long periods.)

Below Cnoc an Sgumain the hills dip to a subsidiary ridge, and down beyond it Loch a' Ghlinne gleams from its hollow like a jewel. Reed-fringed, and with its surface a raft of water-lilies, it has a fine stand of protecting trees on its northern shore – Dalavil Wood. In the valley-bottom a good-sized stream glistens between the alders along its banks, but when reached is easily crossed, even in the semi-spate which in 1998 became the norm in this wettest of springs and summers. Sheep and cattle

graze untended along both banks of the Abhainn a' Ghlinne Mheadhonaich, and on a hillock on the northern flank of the glen a large herd of red-deer, hinds and calves, sprawl in the heather at warm midday; just one alert matron stumbles quickly to her feet to watch intently as I pass. On the edge of the woods, the ruins of houses lie in the centre of a green meadow cropped by sheep to the neatness of a lawn. One single chimney-stack stands in mute memorial, and the traditional rowan-tree shelters only the carcase of a yearling lamb, not long dead but staring blindly at the sky from bloodied, empty eye-sockets. Crows' work.

Today, Dalavil Wood (Coille Dalavil) and Loch a' Ghlinne are together a Site of Special Scientific Interest, fenced off for protection from sheep and deer, both of which browse avidly on the shoots of young trees. The two-meter fence is an unwelcome intrusion in this ancient landscape but serves its purpose well, and the woodland floor is carpeted with tree-shoots. Under the first trees another roofless cottage is smothered in bracken almost to its lintels, and has a vigorous rowan growing from its western gable. There is a quite other-worldly feel to these woods – stronger than I have felt in similar places – a primeval quality almost as if they had never heard a human voice, and under the tall, straight trunks there is the hush of the cathedral. A breaking twig beneath my boot cracks like a pistol-shot in the silence. There are two groves of pines near the margins of the loch, and many other native species: rowan, hazel, holly, birch and oak;

but also magnificent specimens of beech and elm, their seeds presumably carried by birds from the wooded policies of Armadale Castle just five kilometers away across the island. Under these stately trees, fallen trunks lie pale among the bracken and sphagnum, rotting imperceptibly to the humus which will fertilize some other year's re-growth. At midday there is a hush over all the tree-tops; the gentlest breeze ruffles the highest branches, and down in the shadows there is not even a breath of movement. And yet, when I stop to listen for a moment, that hush is more apparent than real, and from all around come the small sounds of birds, mostly unseen, though a nearby rowan is alive with the bustle of a whole clan of wrens – I have never seen so many at one time – which challenge me cheekily as I approach.

The wood is only a kilometer long, and all too soon the foliage begins to thin out at its northern fringes. At the water's edge a solitary heron lifts away as I emerge from the trees. What remains of the glen is less interesting. Wide, flat, boggy, the watercourse dredged and straightened until it looks more like a canal than a highland burn; there is no more to do than tramp another twenty minutes or so to the tin-roofed cottage at Dalavil, where it will be almost time for lunch.

The corrugated iron is well-rusted, and the door-less, windowless cottage has long been no more than a shelter for the sheep whose droppings litter its earthen floor. Close by, a knee-high outline is all that remains of another dwelling; west across the

river and hard to spot in the sun-glare, a much bigger township, Caradal, lies quietly mouldering in the bracken. Where once there was life and vitality there is now just an occasional passer-by like me, or the fishermen I meet around the corner on the shore, who had crossed the moors on an all-terrain vehicle and were pulling mussels from the rocks to use as bait on sea-lines. This western coast of Sleat is wild; and lonely once I leave the mussel-gatherers out of sight behind. Waves slap at the foot of tall cliffs, and kittiwakes wheel on a rising wind.

The Cuillin, nearer now, has gained a grey cap of cloud, and the westering sun slides over the hills of Rum and glints from the wave-tops of a dark sea.

On this first day of the walk I am unfit and ready to quit by mid-afternoon. The bigger streams have carved deep gullies through the slopes above the clifftops, and there is many a scramble in and out of these. I want to stay close to the cliff-edge, to be on the lookout for seal and otter, but this coast is deeply notched by coves and ravines, and there are too many detours to be made around them. At two or three points I take to the stony beaches, (one has a natural arch of beautiful, pale rock) only to be forced back to the clifftops by the sea which sometimes leaves no space for a path beneath the crags. At last a low triangular headland appears at the base of the cliffs and, beyond it, the beach at Gillean. Soft turf eases my steps down on to an arc of dark volcanic sand, and in a few minutes I am on the narrow Tarskavaig road.

Tarskavaig is an immensely picturesque village,

with its backdrop of Loch Eishort and the Cuillin, whose image has been presented worldwide as that of a typical crofting township. It was founded in the early 19th century as a "clearance village", to which people who had been evicted from elsewhere on Clan Donald lands were re-settled, given tiny allotments on its poor, thin soil and expected to harvest kelp from the shore to make their living.

Today little real crofting, if any, is done and Tarskavaig's population of mainly retired local people, with a few newcomers, is typical of much of Skye. In contrast to the desolate interior, this small part of Sleat is fairly well-settled, with townships at Auchnacloich and Tarskavaig, and other small communities at Tokavaig and Ord. Between them all, however, they boast not a single shop nor any public amenity larger than a telephone kiosk, so that all supplies must be brought at best from Ardvasar, a twenty-five kilometer round-trip or more over the narrow, switchback road.

The road which connects these villages runs for long stretches through mixed woods of all the usual native species, the more exposed of the trees stunted to a fraction of their normal size, and bent and twisted by the prevailing westerlies to which this coast lies exposed. At the fortified headland beyond the stony bay of Ob Gauscavaig, the ruins of Dunscaithe Castle deteriorate with each passing year but are all that remain of one of the most historic sites on Skye, fought over by the MacDonalds and the MacLeods for centuries in their epic wars for control of the island and the Isles. Offshore on

Eilean Ruaridh there are ancient fortifications, and further east more recent remains – the bones of another cleared township – face each other across the pretty inlet of the River Aulavaig. Today this empty stretch of coast between Dunscaithe and Ord is home only to otters, seals and herons. Though at other times I have walked the coastline, on "the walk" I keep to the road which dips and swings through the woods between Tokavaig and Ord, with the spring songs of blackbird and thrush to keep me company.

The Tarskavaig road

Sheds at Tokavaig

DAY TWO, AM. ORD TO DRUIMFEARN (7.5kms, 1/2 day, height-gain 100m). From Ord, the shoreline is followed all the way to Druimfearn, recognisable only by a couple of moored boats and a track which comes down to the shore at the same point. The village itself is not visible, hidden by the fringe of woods behind the shoreline. The beach is rocky and uneven, and the walking is hard. When the tide is up, the shore is covered virtually to the tree-line, and the walker must make use of the (frequently heavily-wooded) slopes above. Navigation is never a problem since the line of the shore is always followed, but these slopes are pathless, with deep vegetation, and the going is never easy. Even at low tide, at various points it may seem more sensible to take to

the slopes above the beach; and if the tide is in filling the estuary of the Allt a' Chinn Mhoir about half-way to Druimfearn, a longish uphill detour may have to be made, to cross the gully down which the stream flows.

DAY TWO, PM. DRUIMFEARN TO HEASTE (7.5kms, 1/2 day, height-gain 40m). The coast is again followed, all the way around the head of Loch Eishort to the small village of Heaste which climbs up above the north shore. The walking is slightly easier than before Druimfearn, but still hard due to the very uneven, stony nature of most of the shore, and the pathless

Seapinks, Druimfearn

hillslopes above it. At low tide it may be tempting to cross the wide estuary of the river which flows into the eastern end of Loch Eishort, but this should not be attempted as the flat bed of the estuary is extremely soft and muddy. The river, Abhainn Ceann Loch Eishort, can readily be crossed (though not necessarily dry-shod) at several points where there are shallows a little upstream from the estuary. B&B can be obtained at several homes in Heaste.

Early morning, high tide. I stroll the narrow strip of beach by the Ord River before setting out on the first stage of the day's long walk to Heaste, fifteen kilometers away around the head of Loch Eishort. Gulls wheel on a soft blue sky, clearing slowly after a night of hard rain, and everywhere underfoot and on the long green spears of the iris-leaves which flank the beach there is the gleam and glint of water. The river is full, too; a lazy brown flood come down out of the Sleat hills to the sea, staining the waves the colours of heather and peat, and as I head off past the huddle of houses along the shore there is the first of the day's many showers, a burst of cold rain brought on a wind which has swung overnight from south-west to north-east. There is a short scramble to pass the last house, whose fenced garden skirts the very edge of steep rocks, and then there is only the empty shore.

Across Loch Eishort the line of cliffs below Beinn Bhuidhe are black, slashed with the white of water-falls, and I wonder whether the coastal path (which I believe to exist but have not yet confirmed) goes below or above them. I cut away from the shore behind Rubha Dubh Ard (High Black Headland), and skirt the deep inlet which follows, as a second heavy shower comes hissing in through the birches on the hillside above, forcing me into shelter below a shallow rock overhang. When it clears, the wind has swung more northerly and brings the distant sound of another waterfall, two kilometers or more away across the loch at Boreraig, and clearly visible as a vigorous spout of white in a cleft of dark rock low down near the shoreline.

The walking on this shore is hard. Sharp pebbles the wrong size for comfort alternate with sloping rock pavements, slick with seaweed and rainwater, but when I take to the slopes above, the young bracken is dripping-wet and at least chest-high in places and I am drenched within moments. It is an awkward choice to have to make but, soon after the loch swings due east, a large birch-wood comes in view and I climb up and away from the shore to get some relief from its ankle-jarring stones. Under the trees the bracken is of more modest proportions, the rain feels less heavy, and there are sheep- and deer-trails which contour the slopes cunningly and give some intermittent but welcome help.

The Allt a' Chinn Mhoir comes down through these woods in a steep-sided ravine of some depth, and soon there is another choice to make – climb the hillside around the upper end of the gully, or descend again to the shore and hope the tide has receded enough to get dry-shod across the broad mouth of the burn. I lazily opt for the little estuary which turns out to be firm underfoot and quite empty except for the narrow stream-bed; I leap the watercourse and turn uphill again into the trees which fascinate me as do all lonely woods. The animal trails are less useful here, the woodland floor a tilting, dripping sponge of sphagnum, grass and heather, and in trying to find drier footing I climb higher up the slope to gain a long mossy ledge I can see cutting through the birches above a small bluff. This is a happy decision, and not only does

the walking improve, but the source of some loud and persistent cronkking is immediately revealed as a large heronry in the trees below the crags.

It must be quite rare to be able to stand on the ground and look *down* into a heron's nest, but that is the situation now as I peer cautiously through the branches into four nests, three of which contain well-developed young. Two nests seem to have only one chick apiece and the last has three, while another four or more nests are too high to see into, though there is movement in some of them. All of the nests are just too far away and too masked by intervening leaves and branches to photograph effectively and I don't dare get any closer in case I scare the not-fully-fledged and nervous youngsters out of the nests, which would be a disaster.

Overhead, the parent-birds wheel and cry in alarm at this interloper. I curb my curiosity and set off again, heading downhill this time for the edge of the woods then out onto the shore to follow the tide-line east towards distant Druimfearn.

On the opposite side of the loch the houses of Heaste dot the hillside, and a yacht, sails furled, chugs by and swings north, heading into the safe anchorage of Loch an Eilean below the township. Somewhere above me on this side, hidden in the birches, lies the ruins of yet another crofting township, Morsaig, cleared of its people in the mid-19th century to make way for a sheepfarmer. Along the lochside, the most memorable feature on the last hour to Druimfearn is a superb oak in full leaf, sprung from a solitary rock on the high-water-mark.

At Druimfearn, two boats and a tractor mark where a rough track comes down from the unseen village to the shore. Out in deeper water, neat lines of large black floats mark where one of the newer marine industries – mussel farming – is bringing at least *some* jobs and income to an area which still needs both. A path, the first I have seen since Ord, wanders east up the coast but peters out within a few hundred meters where the loch abruptly narrows and enters the estuary of the river, Abhainn Ceann Loch Eishort ("The River at the Head of Loch Eishort"). With the tide now receding fast, the estuary is almost empty, and there is a temptation to try to save a kilometer or two by cutting straight across, but a couple of brief essays out on to its deep mudflats convince me otherwise, and I beat a retreat to terra firma the second time with evil-smelling liquid mud up to my boot-tops.

Finally I cross the river just where it enters the estuary and splits into several braids; the last and deepest channel is too wide to jump and just deep enough to give me wet feet for the first time today.

The walk along the north shore of the loch to Heaste in many ways mirrors the earlier part of the day on the south side, but the walking is a little easier. The rocks on the beach are seldom rough enough to force me onto the hillside above, and when they do there are more useful sheep-tracks and less energy-sapping bracken and sphagnum. It begins to seem a very long way – feet getting tired – and I am beginning to look with some anticipation for a sign of the village when I do get mired in

deep, soft moss when taking a detour behind a small headland. Just then a watery sun comes out (the first since 9am) and the illusion of warmth is enough to have me shed one layer and find a comfortable rock to rest on. Not twenty meters offshore three seals gaze intently and seem to listen as I crouch to whistle and call softly to them, their black-labrador heads bobbing in the dark water. When I approach closer to the edge of the rocks they vanish in a silent swirl of water, to reappear a hundred meters further out in the loch.

The last hour into Heaste is a plod, with tiredness gaining, along a stony foreshore which as I near the village shows signs of vehicle-tracks. There are work-boats here, a fish-farm moored out among the skerries, and a good-sized prawn-boat hauled up on the shore, stacked creels and pallets, and all the detritus of a small fishing-station.

There is no-one around. At the slipway, two herring-gulls squabble over some fishy morsel while others perch gloomily along the rail of the boat, shoulders hunched against the still-cold north wind, eyeing me bleakly as I head towards the first of the houses to enquire after a bed for the night.

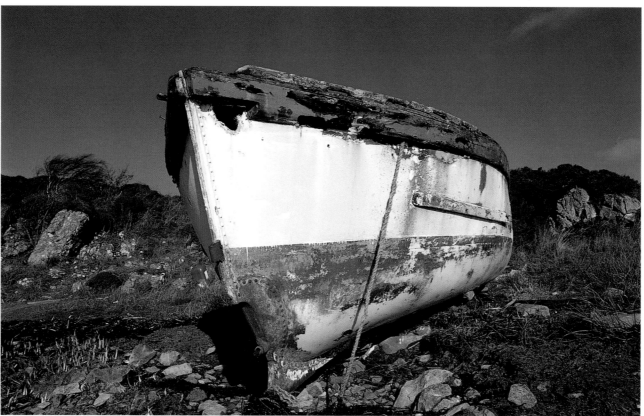

Wreck at Heaste

Wreck at Ardvasar

Woods at Ardvasar

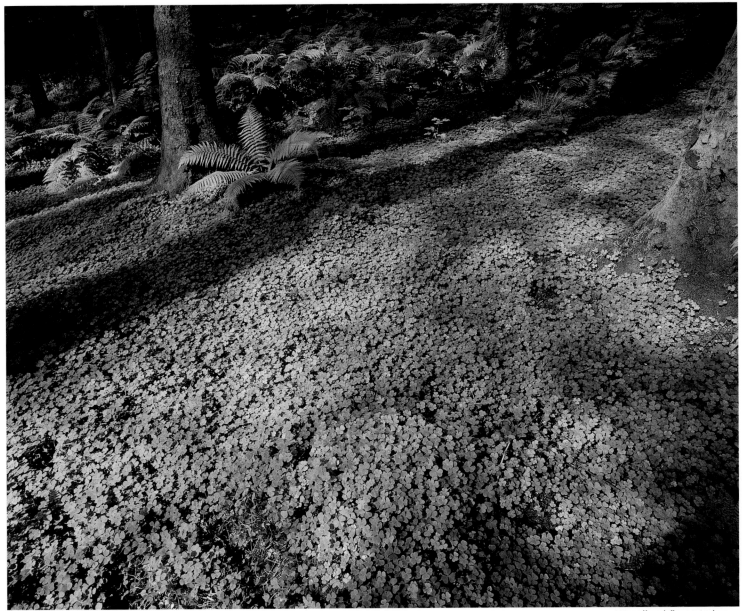

Woodland floor, Ardvasar

The interior of Sleat

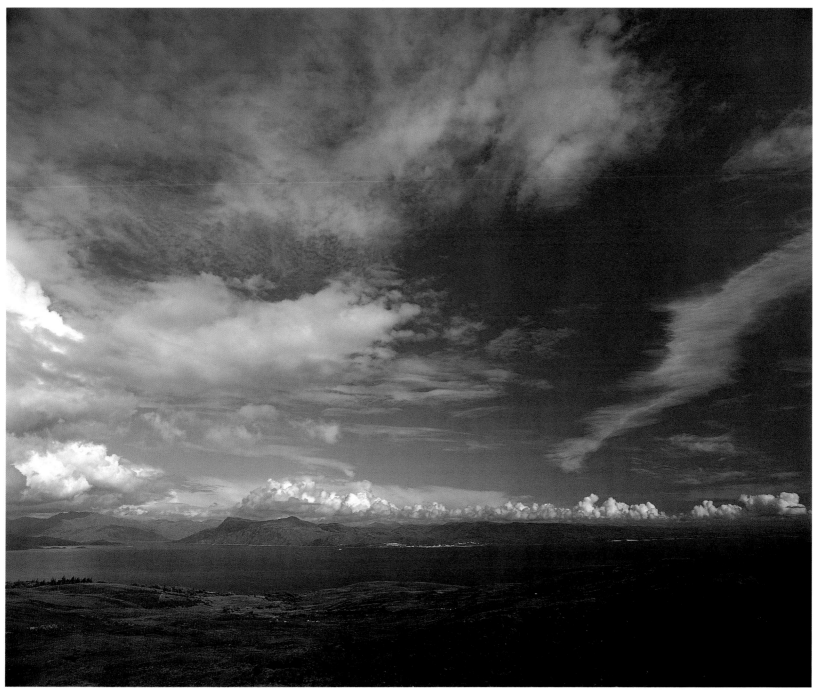

The Sound of Sleat and the mainland

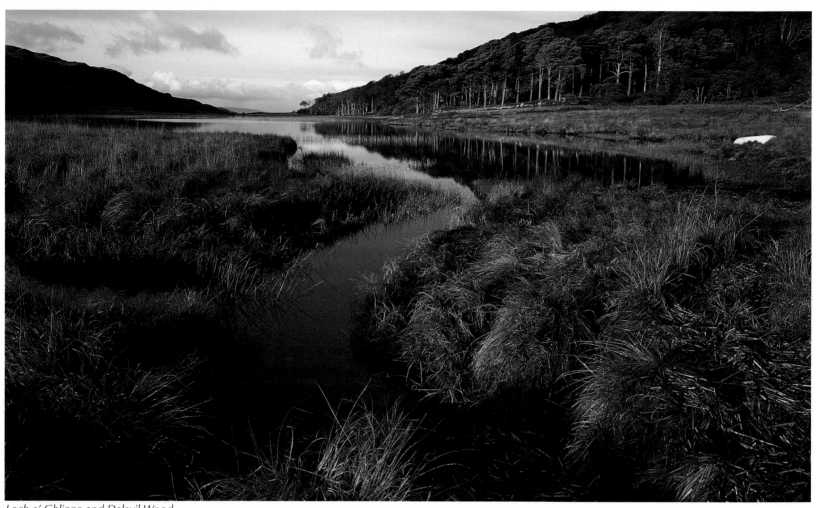

Loch a' Ghlinne and Dalavil Wood

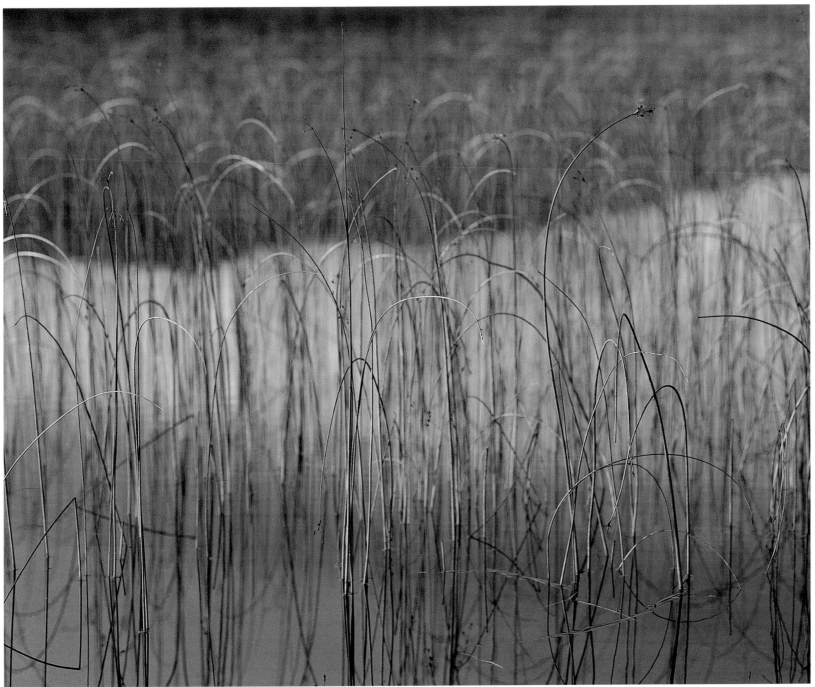

Reeds on Loch a' Ghlinne

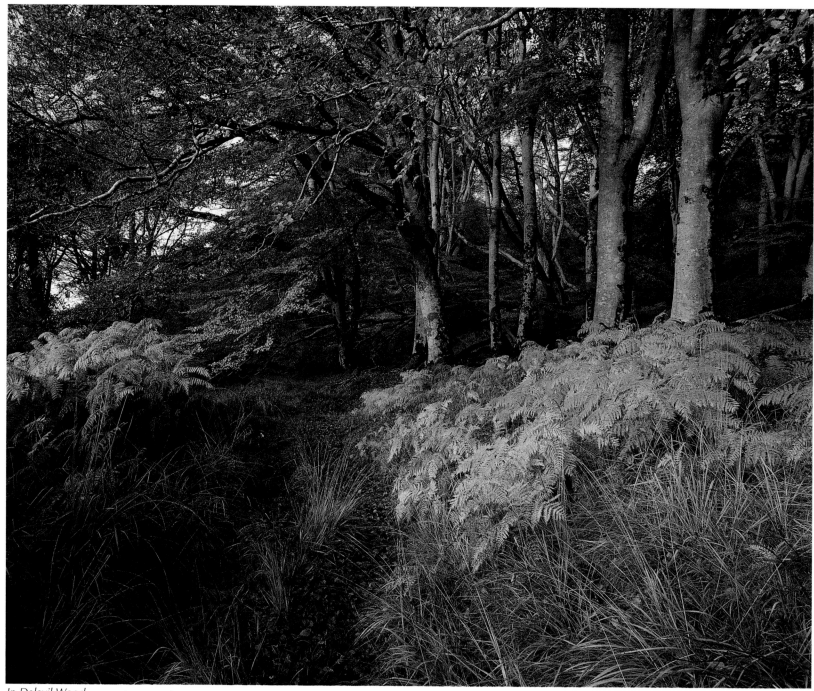

In Dalavil Wood

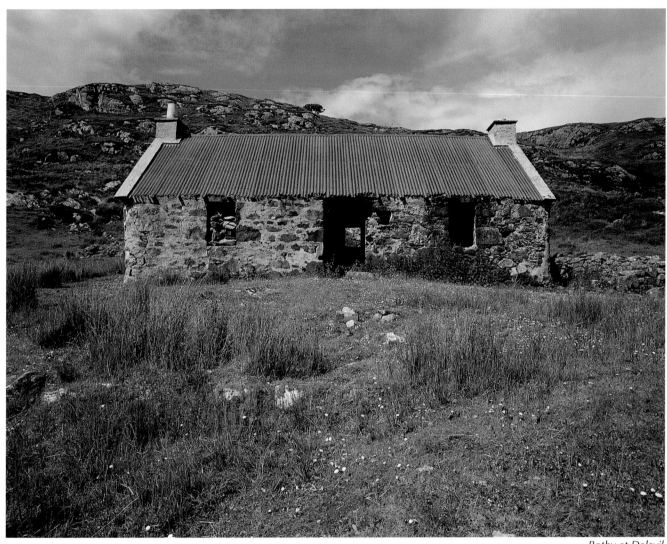

Bothy at Dalavil

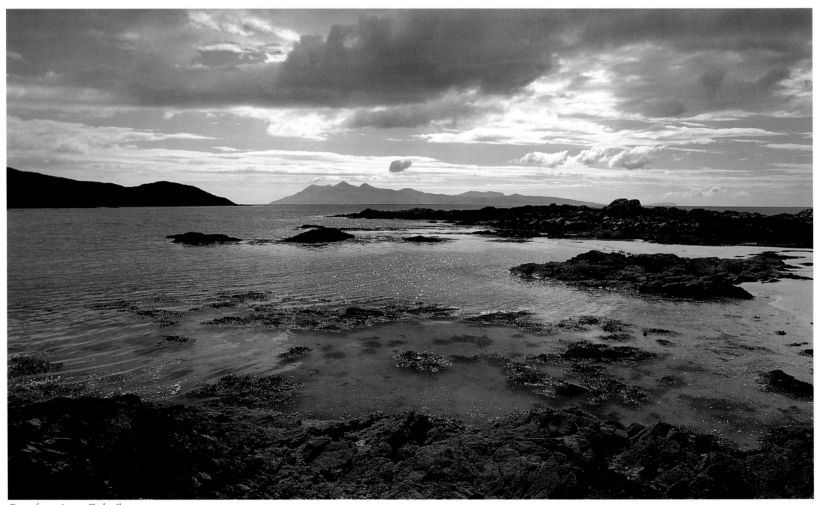

Rum from Inver Dalavil

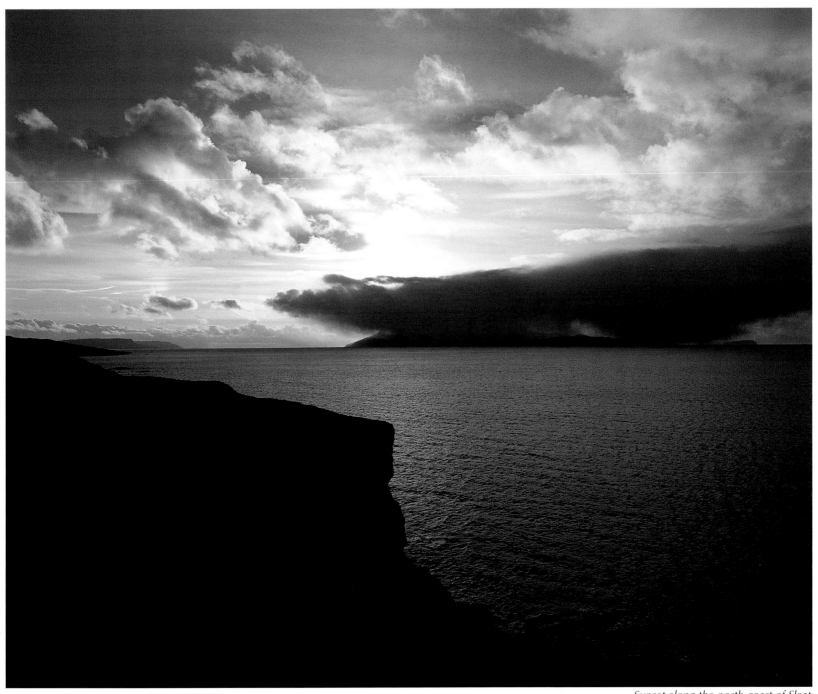

Sunset along the north coast of Sleat

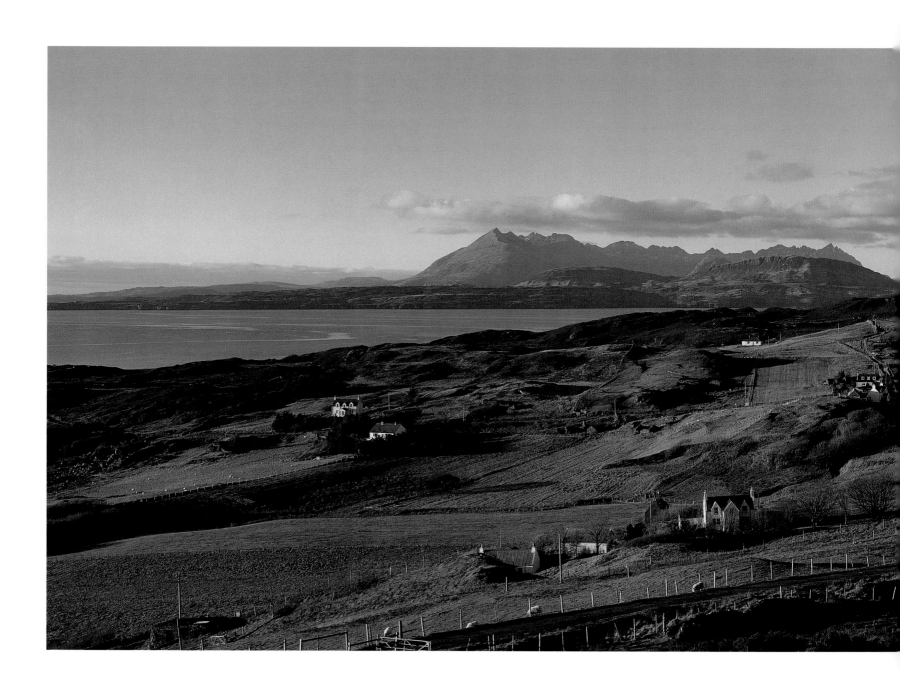

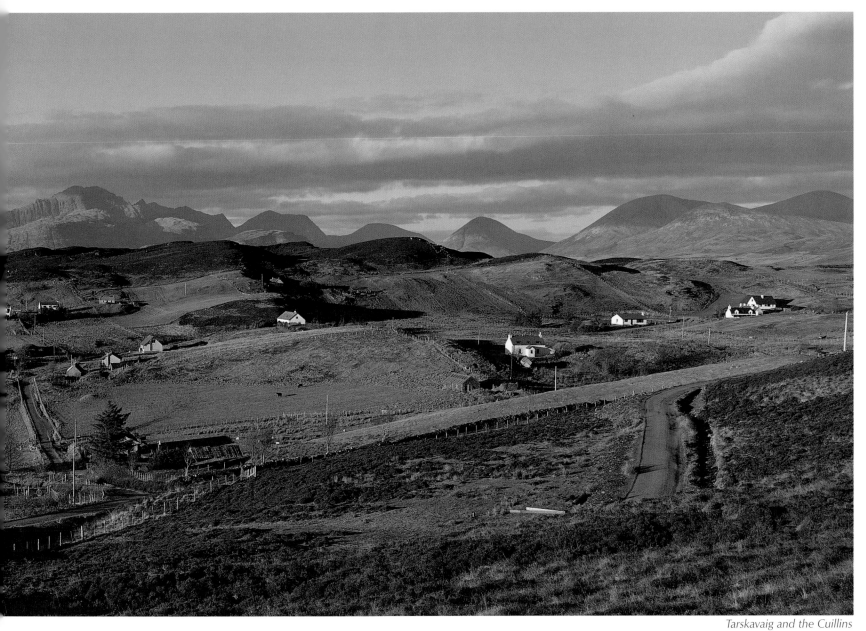

Tarskavaig and the Cuillins

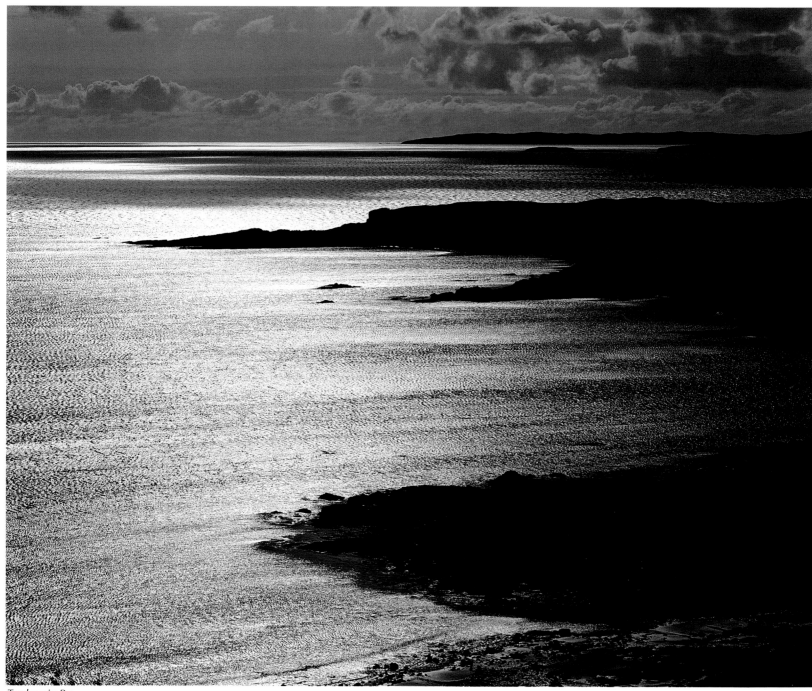

Tarskavaig Bay

Woods near Ord

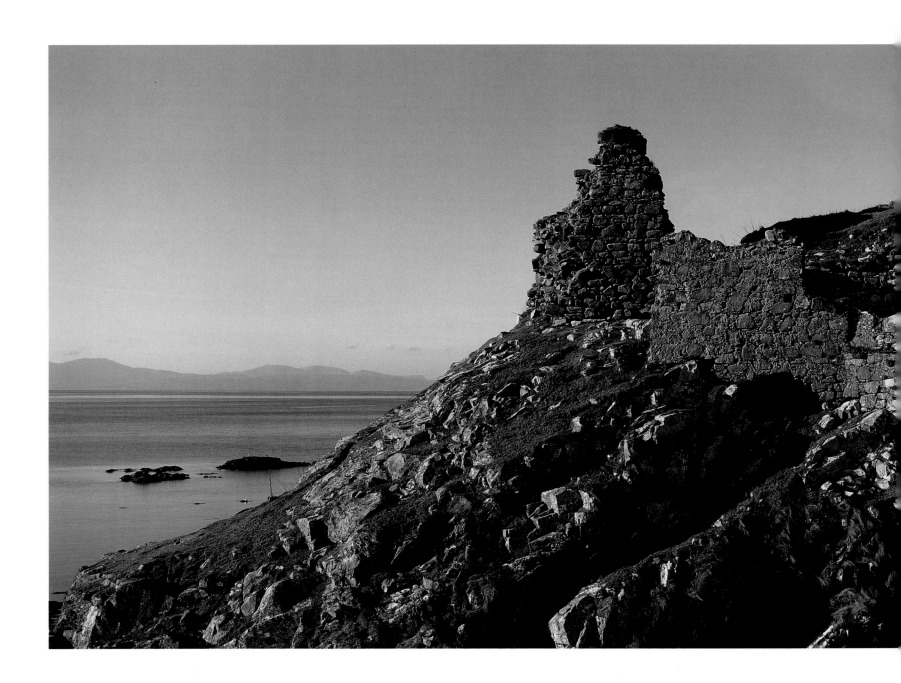

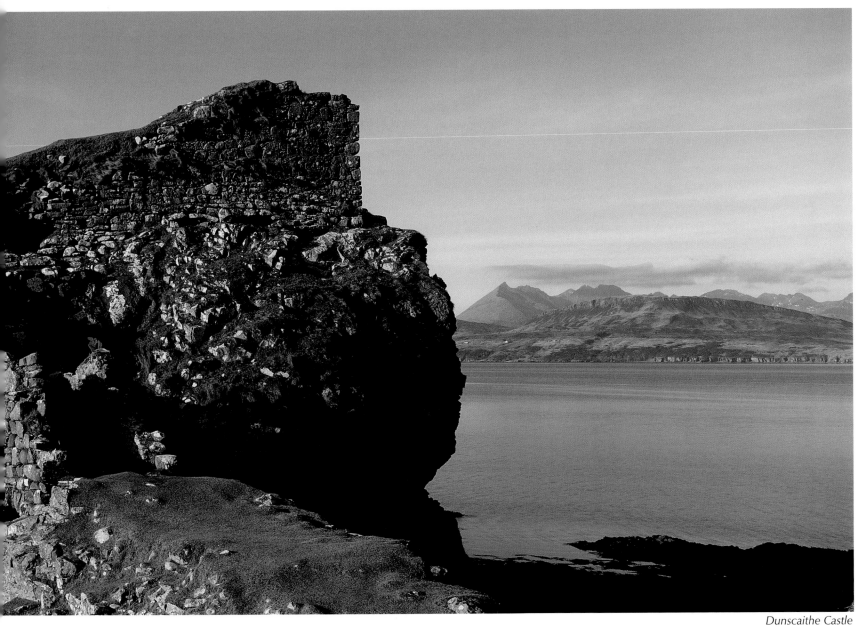

Dunscaithe Castle

Loch Eishort at Ord

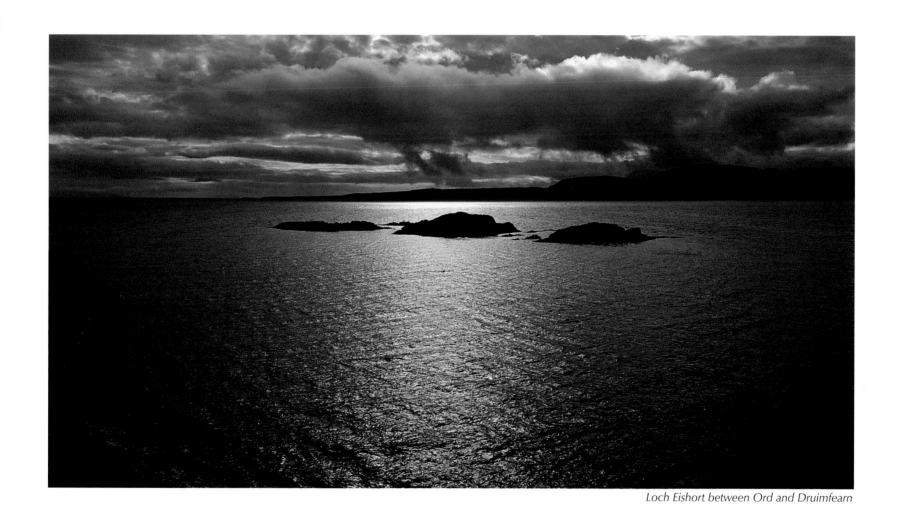

Loch Eishort between Ord and Druimfearn

Autumn trees at Allt a' Chinn Mhoir

The village of Heaste

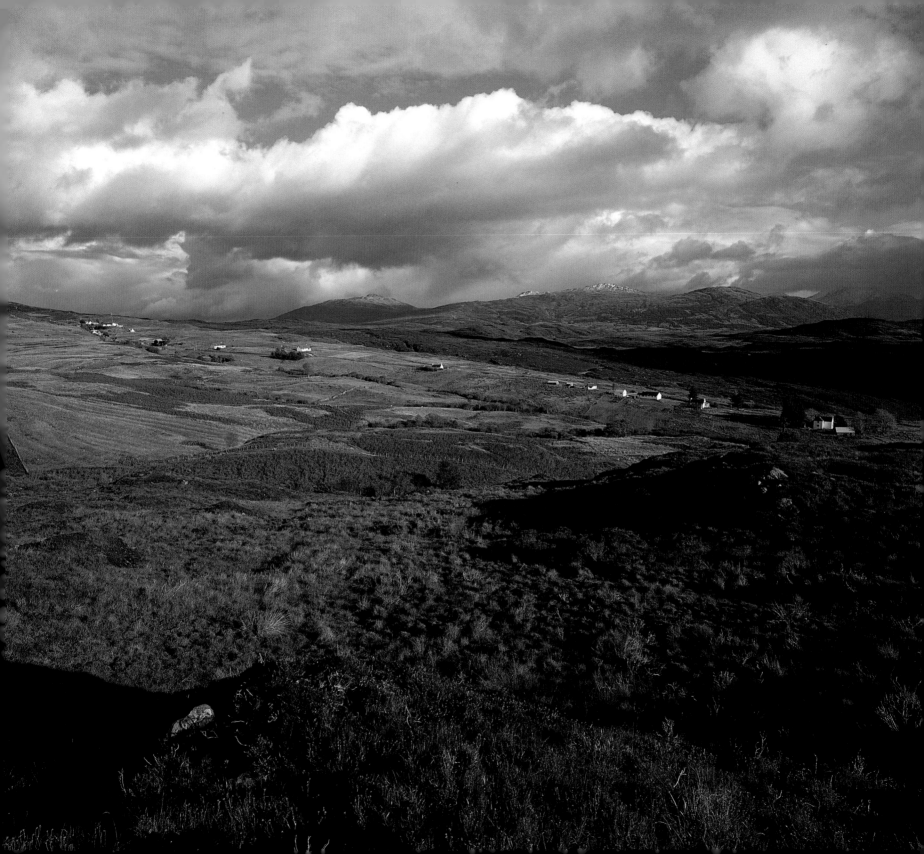

DAYS 3/4 HEASTE - SLIGACHAN

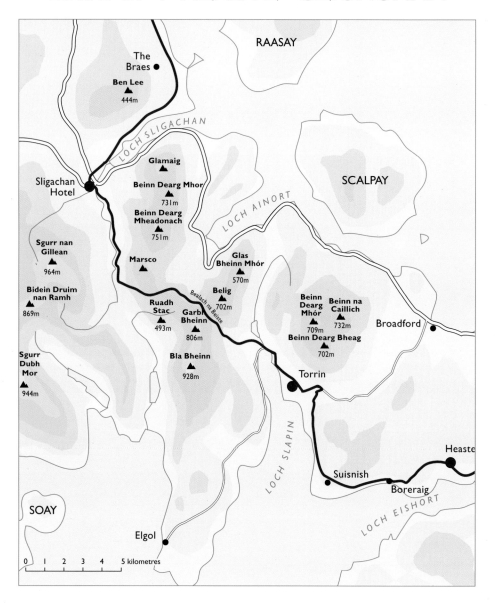

RAASAY

The
Braes ●

Ben Lee
▲
444m

LOCH SLIGACHAN

Glamaig
▲

SCALPAY

Sligachan
Hotel ●

Beinn Dearg Mhor
▲
731m

LOCH AINORT

**Beinn Dearg
Mheadonach**
▲
751m

**Sgurr nan
Gillean**
▲
964m

Marsco
▲

**Glas
Bheinn Mhór**
▲
570m

**Bidein Druim
nan Ramh**
▲
869m

Belig
▲
702m

Bealach na Beiste

**Ruadh
Stac**
▲
493m

**Garbh
Bheinn**
▲
806m

**Beinn
Dearg
Mhór**
▲
709m

**Beinn na
Caillich**
▲
732m

Broadford ●

Beinn Dearg Bheag
▲
702m

**Sgurr
Dubh
Mor**
▲
944m

Bla Bheinn
▲
928m

Torrin ●

Heaste ●

LOCH SLAPIN

Suisnish ●

Boreraig ●

SOAY

LOCH EISHORT

Elgol ●

0 1 2 3 4 5 kilometres

DAY THREE, AM. HEASTE TO SUISHNISH (7kms, 1/2 day, height-gain 130m). Near the foot of the village of Heaste descend westwards a few meters to the small stream and belt of trees which lie behind the croft-houses. A flagstone footbridge crosses the stream and a sketchy path then leads into and through the trees. This vestigial path, often no more than a furrow in the heather, leads up over a rising moor towards the small hill called Torr Mor on the OS map. Traverse on the seaward side round an obvious shelf below the summit of Torr Mor. The ruins of Boreraig soon appear, spread out below you. Descend to the shore, skirting a picturesque waterfall (falling almost directly into the sea) and climb easy rocks fur-

ther along the shore up to this ruined crofting township. The path, now broad and easily followed, continues west along the coast (passing another two ruined crofts) below high black cliffs with further waterfalls and fine sea-views back down Loch Eishort. It then climbs steeply but easily up through the cliff-line about one kilometer before Suishnish Point. On the clifftop there is a large shearing-shed and another abandoned crofting village.

DAY THREE, PM. SUISHNISH TO TORRIN (7.5kms, 1/2 day, height-gain 30m). Beyond Suishnish the route turns sharp right to follow the south shore of Loch Slapin. The footpath soon becomes a good Landrover track winding across an undulating moorland which reaches all the way to the edge of the cliffs above Loch Slapin. The cliffs reduce in height as the track is followed, and eventually a flat area, popular with walkers as a carpark, is reached above the stony beach of Camas Malag. From here, it is possible to continue following the shore all the way to just beyond Torrin. It is preferable for variety's sake, how-

Detail, Boreraig

ever, to take the rough tarmac road from Camas Malag to Kilbride, at the junction with the single-track Broadford to Elgol road. Turn left on to this, and follow it past the marble-workings and through woods on the outskirts of the village of Torrin, into the village itself. B&B is available here in the summer months.

On my first walks through here in spring, and later in summer, I kept to the coast all the way from Heaste to Boreraig, and this was a mistake. Just like the opposite shore of Loch Eishort, this side was rough, trackless and hard walking. Later by asking in the village I soon found that there was an ancient track to Boreraig which kept away from the shore and was both easier and shorter, but does not appear on modern maps.

By September the narrow band of hazel-woods behind the township is yellowing, and the drying leaves rustle in a warm breeze as I duck beneath low branches; two small streams have elemental bridges formed by single flagstones laid across the water, and on a grassy hillock not far behind the present-day village the knee-high remains of a much older settlement are blurred under turf and bracken. The track leads up onto a rising moor where cattle graze and chew and follow this unknown human with their long-lashed dark-brown eyes. One mother licks her offspring's head and neck vigorously, the calf raising its head with eyes half-closed in ecstasy to allow its throat also to be licked. The trail is indistinct, perhaps even imaginary or non-existent, but the route is clear. A broad shallow gully leads up to the first of two easy heathery ridges which must be crossed, and a long shelf curves gently round towards Torr Mor whose outline soon appears on the near skyline. From the hilltop, Boreraig is spread below like a map. The remains have an atmosphere at once poignant and powerful, and all kinds of equivalents spring imme-

diately to mind – the ancient ruined cities of the Turkish Mediterranean, Macchu Picchu (in the glen instead of on a mountain-top) and other vanished peoples and lost civilisations. And that, of course, is exactly what these ruins represent – the lost civilisation of the Gael.

Once down among them, physically the most impressive are the house and byre of the tenant farmer for whose benefit the village was cleared; around the perimeter of the township the tumbled cottages peer down in reproach at the usurper in their midst. Boundary walls and field-clearance cairns are everywhere, and in one corner a single standing-stone hints at an even longer history. Within the highest walls still standing, someone has recently made a shelter – ropes are stretched to support a roof of plastic sheeting, fish boxes gathered as furniture and at least one large brown crab has been roasted over a driftwood fire. Nearby, the dead heron I photographed in spring has returned to Mother Earth, and only a scatter of flight feathers and a vivid patch of grass, taller and bright green against the fading autumn colours of the meadow, marks the spot.

There is much to explore here apart from ruins. Down on the rocks of the shore, a few minutes' patience will surely bring a seal or two, and on a lucky day a pair of otters; there are seabirds, divers, duck and heron. The waterfall which guards the eastern approaches to the township is remarkable enough, its sea-pool only a step from the sea itself, and across its cliff there is the richest seam of fos-

sils I have ever seen (which surfaces again on rock pavements below the village). The tree-lined watercourse above is a minor gem of deep-etched rock-pools, slides and cascades, and at this season the birch, rowan and hazel which wave and jostle in the breeze are every colour from pale gold to dark emerald, splashed with the scarlet berries of the rowans. I pick brambles and small green hazelnuts for lunch where, a hundred and some years ago, the children of Boreraig surely did the same.

But the path leads on, and towards Suishnish there really is a path. Up a little at first to pass behind a miniature headland whose crags at any season are a garden, festooned with ivy, seapink, fern and a score of other species I cannot name, the way soon leads below gaunt black precipices of crumbling volcanic aggregate; at intervals waterfalls hiss down and occasionally there is the rattle of a stone. I find my footsteps hurrying in case one loud noise should bring the whole mass toppling over, but reason that these cliffs have stood for centuries and there is little chance that they will fall today. In a corner, tucked into this narrowest of gaps between shoreline and cliff-foot, lie two more ruined cottages. Before Suishnish, the path climbs steeply but without difficulties to a notch in the cliff-line. With every uphill step the backwards vista along Loch Eishort opens out, but at the top the view ahead is not of another abandoned settlement, as I had expected, but of a large, modern, green-painted agricultural building.

After this surprise, I take a look around the shearing-shed before climbing up to Suishnish, whose piled stones I can now see dotting the slopes immediately to the north. In the shed, as well as the wide areas for shearing and storage you would expect, there are partitioned-off living-quarters; hardly luxurious, but comfortable enough with bed, table and chair, a cooker running off bottled gas, and a sink whose single tap gushes clear cold water immediately it is turned. It would be cheeky ever to stay overnight here without first seeking permission, but I can't help making a mental note of a possible hideaway. In winter, especially, it would be fine to come to such a lonely spot and be able to spend a night or two under a roof instead of in a tent.

Today, it's not so lonely. I have already met one couple on the way from Boreraig, and on this mild afternoon, the easy walk from Camas Malag to Suishnish has proved attractive to a few people, who like myself tut and frown a while among the ruins. The houses are well-separated on their meadow, sloping down to the cliff-edge, its turf invaded by heather and rushes after the long years of neglect, but still with the vestiges of paths and walls which once knitted the township together. Few of them can boast any wall or gable much above waist-height, and only one still carries any sort of roof – of rusted corrugated iron – and inside its empty doorway the bloated carcase of a sheep lies amid filth and ordure. Against one gable-wall the remains of an iron bedstead lie where they were stacked a lifetime ago, but are crusted now

with decades of rust and bird-droppings. There are no other visible clues to the lives that were lived here, not so long ago.

Maps show a path from here to Camas Malag, but a motorable track is a more accurate description, and the walking is easy. Beside this undulating road across a rolling moor further ruins are visible off among the heather, but the afternoon weather has begun its usual deterioration, and I don't pause to investigate. A high skein of cloud covered the sky as I tarried at Suishnish, and now lower, darker cloud races quickly from the west up the skies above Loch Slapin. Not too anxious for a soaking,

I accelerate my pace as the track winds down towards the beach at Camas Malag. Here, there is a choice to be made. The shore can be followed to a point just beyond Torrin, a track can be taken north-east to Kilbride and the road then followed to Torrin, or it is possible to strike straight ahead, cross-country, towards Torrin itself, and as the first heavy raindrops begin to smack the ground beside me, I opt for the latter. There is a burn to ford, and a couple of fields to negotiate without damage to their fences, but in half-an-hour from the beach I am among the scattered houses of Torrin, enquiring after bed and breakfast.

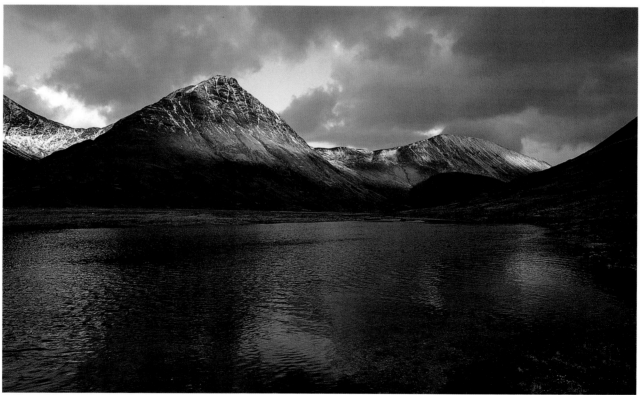

Belig and Strath Mor, north of Torrin

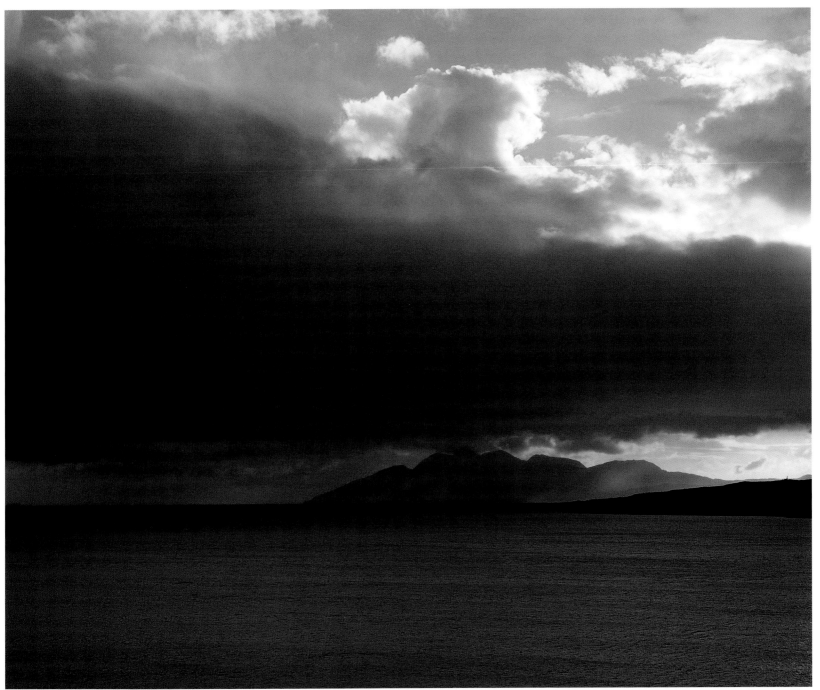

Loch Slapin and Rum from above Camas Malag

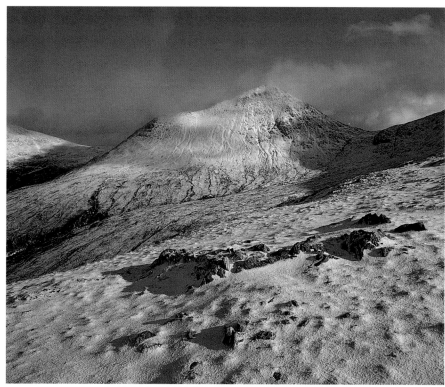
Belig in winter, from Druim Eadar Da Choire

DAY FOUR, AM. TORRIN TO POINT 489 (6.5kms, 1/2 day, height-gain 650m). From Torrin follow the Elgol road round the head of Loch Slapin. Soon after crossing the bridge over the Abhainn an' t-Stratha Mhoir, strike out right across moorland towards the mouth of the corrie contained by the twin east ridges of Garbh-bheinn. Follow the east bank of the stream, which comes down the corrie, climbing steadily for at least one kilometer until the corrie curves sharply to the left, and the pass called Bealach nam Beiste is clearly visible above and to the right. (This is the pass between Garbh-bheinn and its north-east outlier, Belig.) Climb diagonally to the right, up steep but straightforward rocky slopes to the bealach which is wide and flat. Drop down a short way over the far side of the pass into the main northern corrie of Garbh-bheinn and contour left (west) around the corrie, following a semi-broken fence until it turns uphill. Descend to cross the lively burn which flows down the centre of this corrie, and continue contouring, now heading north, below steep black cliffs. Soon a broad, easy, grassy gully can be seen cutting leftwards up through rocky slopes. Follow the gully up to the crest of the ridge, turn left and follow the ridge up to the summit of point 489 (Druim Eadar Da Choire), which has uninterrupted 360-degree views.

Torrin woods

DAY FOUR, PM. POINT 489 TO SLIGACHAN. (8.5kms, 1/2 day, no net height gain). Drop down, heading due west, to the unnamed bealach between this top and the south ridge of Marsco (The Peak of the Gulls), and from the bealach continue west, trending slowly downhill into Am Fraoch-choire (below the north face of Ruadh Stac – acres of steep naked rock, deeply scored by gullies and ravines), passing a small group of ruined shielings on the way. At length a vestigial path appears along the north bank of the stream in the corrie-bottom which can be followed to the junction with the broad footpath in Glen Sligachan. This is the Sligachan to Loch Coruisk path. Turn right on to it and follow it beneath the northern extremity of the Cuillin – Sgurr nan Gillean and its fantastic Pinnacle Ridge – all the way to the Sligachan Hotel. There are normal hotel facilities here (which are cheap, off-season), and a campsite.

Just north of the last houses of Torrin, the lower slopes of Beinn Dearg Mhor rise from the side of Loch Slapin. For many years this area was quarried by Skye Marble for the decorative white stone which has been one of the island's principal commercial products. Quarrying activity has moved away a few kilometers, but here above the shore the litter of rusting Nissen-huts and abandoned plant has long been an eyesore which cried out for removal. Industrial Britain has some way to go to develop the consciousness (and conscience) which will enable sustainable development of rural resources, but perhaps in this particular area the presence of the John Muir Trust has helped. The Trust, which is dedicated to the proper management and conservation of countryside and wilderness areas, recently purchased the Torrin Estate (as well as a large part of Strathaird, across Loch Slapin) and has become a major local landowner. Perhaps its influence was responsible for the clean-up which began in autumn 1998, and may see the eastern shore of one of Skye's most beautiful fjords restored to something like its rightful state.

On a bright early morning I am soon past the old quarry and round the head of the loch to where my route cuts away from the road across a stretch of moor and into the mouth of the corrie which rises to Bealach nam Beiste. It seems clear that I should follow the right bank of the stream coming down the corrie. In its lower reaches the burn is dull and without much interest, flowing sluggishly over peat-stained rock; higher up, as the ground steepens, it soon becomes more lively, its bed transformed into a charming series of smooth white quartz baths connected by short glissades and miniature falls. In a grassy corner halfway up, where a small sidestream joins the burn, I suddenly come across the tumbled walls of two cottages, lying in the shelter of a rocky shoulder. It seems unlikely that these were ever permanent dwellings, in such an isolated place. More probably they were summer shielings, where people would come for a month or two at the warmest time of year, to take advantage of good grazing for their beasts along the banks of the stream, and to make butter and cheese from the rich milk.

Soon the steepening floor of the corrie is bare of any grass, and I begin to look for the most likely way up to Bealach nam Beiste, now high up over my right shoulder. As it climbs, the upper half of the corrie swings hard west towards the high pass between the summits of Garbh-bheinn and Sgurr nan Each, and though this, too, is a possible route it is not where I want to go. Above me a long shallow rake slants back, up and right, to end at easy ground a little below the bealach; I head for this, and in twenty minutes am making the last pull up to the broad, heathery col. New vistas open out almost immediately to the east; a deep corrie drops away at my feet and below it Loch Ainort and Skye's east coast. Offshore, Raasay is lit by thin sunshine. A cold north wind blows hard across the bealach and sends me scurrying down into this north-eastern corrie, out of the blast, to contour

leftwards round its rocky slopes and across a couple of streams, hunting for the way up to the next little bealach I hope to cross. A sudden movement high to the left catches my eye – a raven has launched itself from the cliffs, soon followed by its mate. They twist and spiral in mid-air for long seconds, flaunting their acrobatic skills, then croak in reproach at this human invader of their territory and disappear over the ridge.

The strength of the territorial instinct should never be underestimated, and the Scottish hills are criss-crossed with its dilapidated and often dangerous fencing. This high corrie under Garbh-bheinn is no exception, but for once the jangling wires prove useful as I follow them on an easy contour-line westwards. All too soon, though, they turn uphill while I search for an quick descent to the noisy burn which runs down the centre of the rough and rocky corrie; once reached, the water is readily crossed and a new contour adopted below steep black cliffs to my left. I am looking for the first really easy way up through these cliffs and on to the ridge above, and it is further than I expected before the crags begin to lie back and a green, grassy gully appears. It is steep but straightforward and takes me all the way to the top, breathless. New views again open out, though I don't stop to take them in, but turn left up the ridge heading for Druim Eadar Da Choire, a minor summit which is just above. The panorama from here encompasses the full 360 degrees, and is truly magnificent. Since crossing the watershed earlier, the east coast of the island has been visible for the first time since Armadale at the start of the walk, and beyond Loch Ainort, far below, Scalpay and Raasay lie along the north-east horizon. Closer, the conical summits of the Red Hills make a bold profile, Garbh-bheinn and twin-headed Bla Bheinn loom over my left shoulder, and the scene is completed by steep Marsco and much of the serrated ridge of the Cuillin. Seeming far, far away, through a gap and outlined against the bright-lit waters of Loch Scavaig on the west coast, Sgurr na Stri stands guard over unseen Camasunary. But the weather is not all that I might wish, and though the sun mostly shines the wind is very cold. I drop down off the summit a little into the lee, to lie in soft grass and eat my nuts and chocolate. Overhead, two golden eagles spiral endlessly on the blue.

In the twenty minutes' rest I take with my lunch a sudden weather-change sweeps in from the east, in the shape of a skein of high cloud which quickly covers most of the sky. Below it, the summits are cloud-capped or have shawls of mist draped around their shoulders, and though none of this looks particularly threatening it gets me to my feet and walking again. From Druim Eadar Da Choire I drop downhill as far as the little unnamed bealach below the steep south ridge of Marsco. From this angle, head-on, the ridge looks very steep, almost vertical – a common illusion, and a common excuse – but in reality it is an easy access route to the top of this bold little mountain. The summit gives truly humbling views, and as the north ridge

is a good and straightforward descent route down towards Sligachan, the traverse of this hill is an excellent variation of my planned route. (However, on my walks through here, trying to define the route, I stick to the lower ground on the basis that a long-distance walk should not seek out extra difficulties.) Instead, beyond the col, there is more contouring to be done across the lower slopes of Marsco, always on a slightly downwards trajectory into Am Fraoch Choire. This high valley is a dramatic place, a narrow "V" formed by the steep south face of Marsco and the steeper north face falling from the whale-back ridge of Ruadh Stac. This miniature mountain, only 1620 feet (493m) in height, is entirely composed of naked rock and has a kilometer-long north face of continuous cliffs, not vertical but savage in appearance and seamed by deep and dark gullies.

A junction is approaching as I head west along Am Fraoch Choire, and the slopes steepen as this side-valley begins its plunge down towards the broad strath of Glen Sligachan. Just before the actual junction, where a burn comes down off Marsco, another three ruined cottages or sheilings lie in two adjacent grassy hollows where this burn runs into Allt nam Fraoch Choire. How many such remains there are, scattered all over Skye; and how densely, compared to today, the island must have been inhabited! You need only walk a few minutes off the beaten track, almost anywhere, to come across ruins just like these. I stop a while to marvel at the placement of the houses; hidden away from

view, sheltered from almost every wind, close to running water, and centred in a patch of rich grazing, and I wonder if such a situation – at the confluence of two streams – held any special meaning or significance for the people who once lived here (as it did in other cultures such as those of many of the Himalayan peoples).

A little further down the slope and round to the north I am back in the world. The Sligachan/ Coruisk/Camasunary track is a broad scar across the landscape; a strip of raw earth up to three meters wide crossing almost my entire field of vision, and disappearing from sight to north and south. With it comes people, for this is probably the most popular route on the island, and down in the glen-bottom the clumps of dark dots which move along the track are walkers. From my viewpoint I can see about two kilometers of path and seven or eight groups of people, and this comes as something of a shock after the solitary nature of the preceeding few days. I think I would try to choose a quiet time of year to walk this particular route (to Coruisk or Camasunary) but inevitably most people have to do their walking at holiday times, and the trail becomes busy. As for the numbers today, actually it is quite surprising to see how many people are prepared to take on such a long round-trip – more than 20 kilometers – on a day which has become both cold and cloudy.

I turn towards Sligachan and soon, of course, am on that very same track, heading north, and after four solitary days find that my antisocial nature has

mellowed a little and that it is nice, for a change, to say hello and be greeted by fellow human beings. The well-used path makes for easy walking and since the weather has turned grey I am not much delayed by photography. Generally I rather stroll along, not hurrying, trying to make sure I miss nothing of interest or importance, but there is a different pleasure to be had now in getting up some speed and generating a little heat in the teeth of the north wind which has been with me almost since the start, back at Armadale four days ago. Sgurr nan Gillean and Pinnacle Ridge have been cloud-capped since I first saw them today and now this cloud is rapidly lowering down their flanks; all around, every other summit disappears into dense white vapour and the entire sky is covered by a higher veil of grey. It doesn't look like rain but I up my pace anyway, looking forward to the luxuries of hot tea and a shower in the hotel at Sligachan.

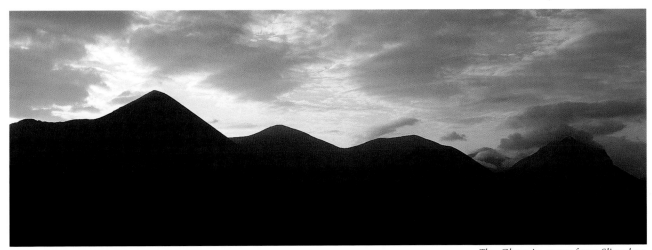

The Glamaig group from Sligachan

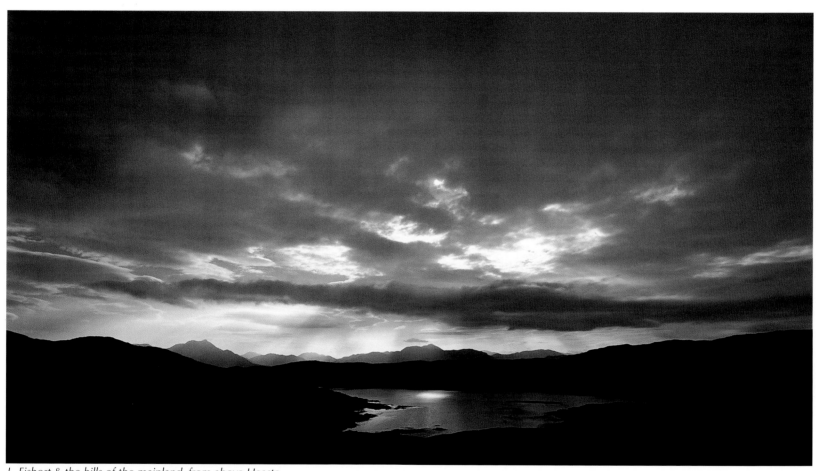

L. Eishort & the hills of the mainland, from above Heaste

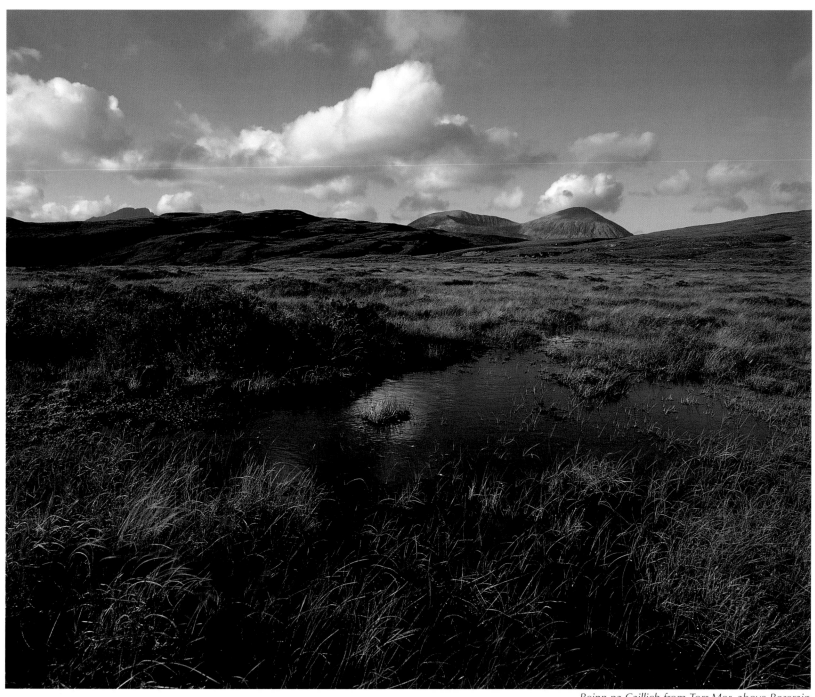

Beinn na Caillich from Torr Mor, above Boreraig

Dead heron at Boreraig

Eas na Muc, Boreraig

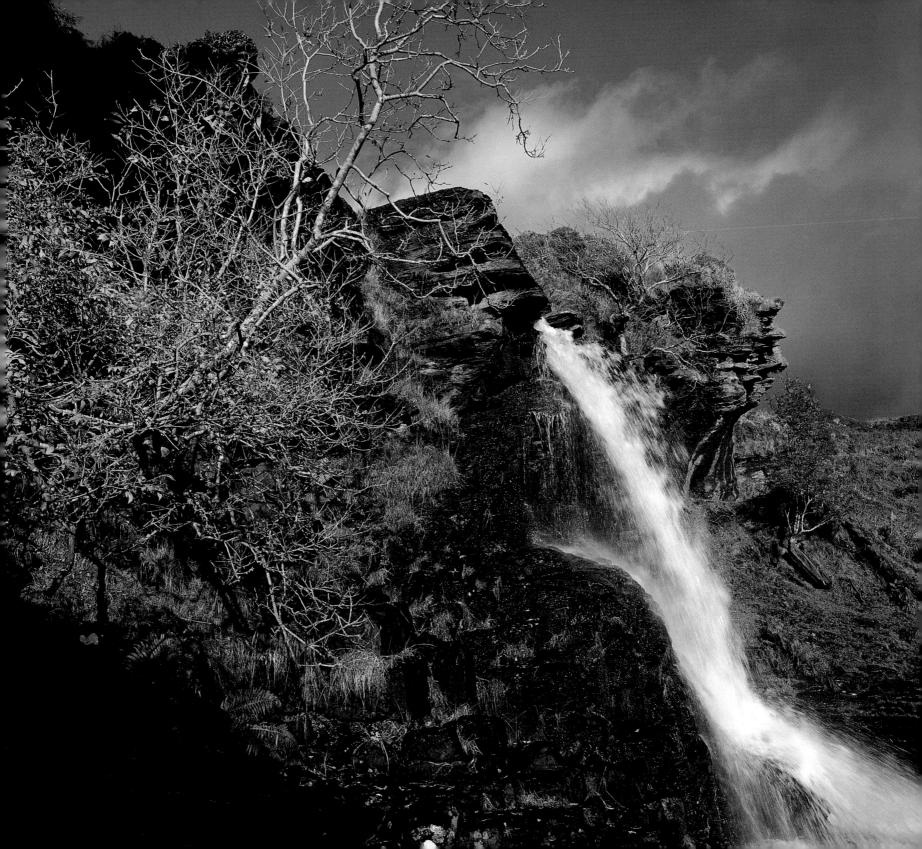

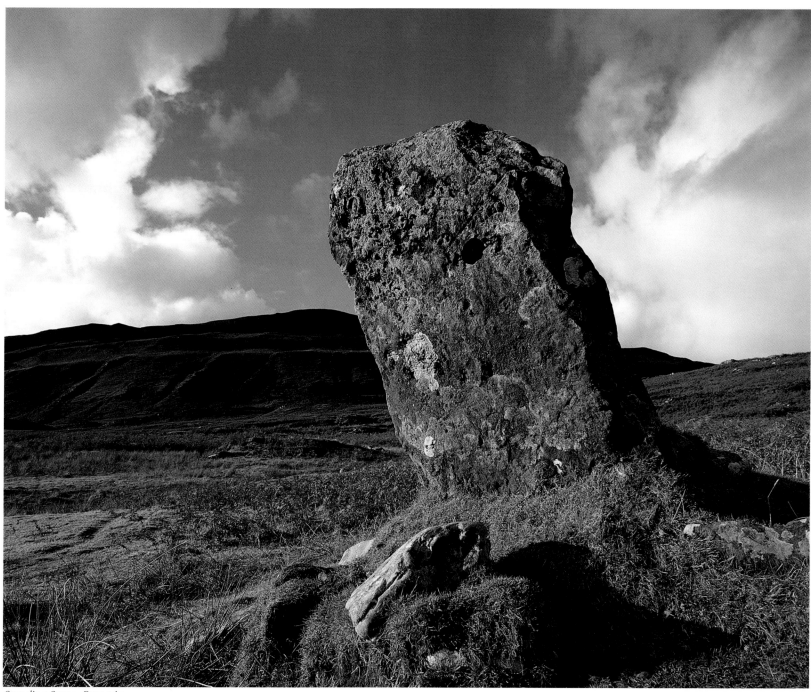

Standing Stone, Boreraig

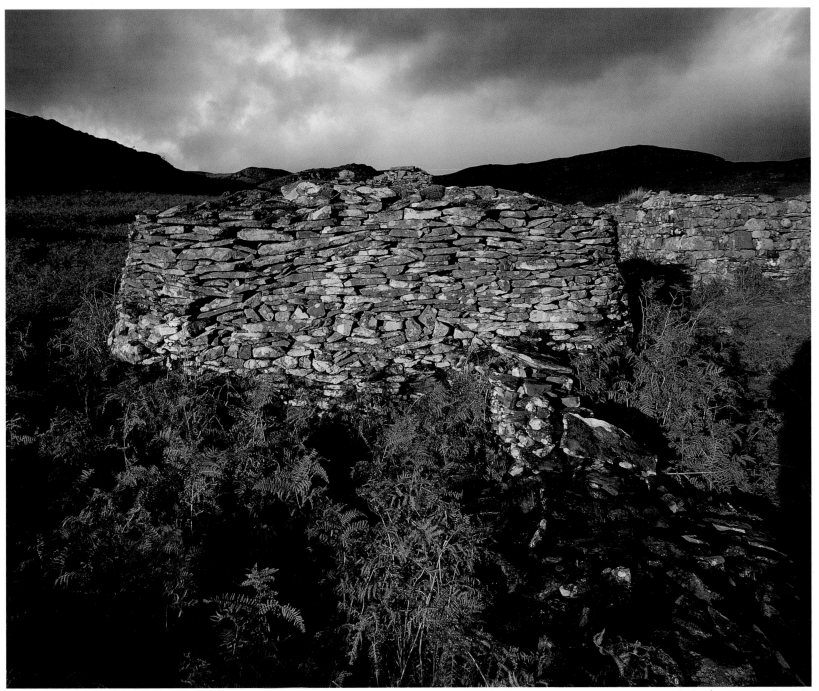

Ruined cottages at Boreraig

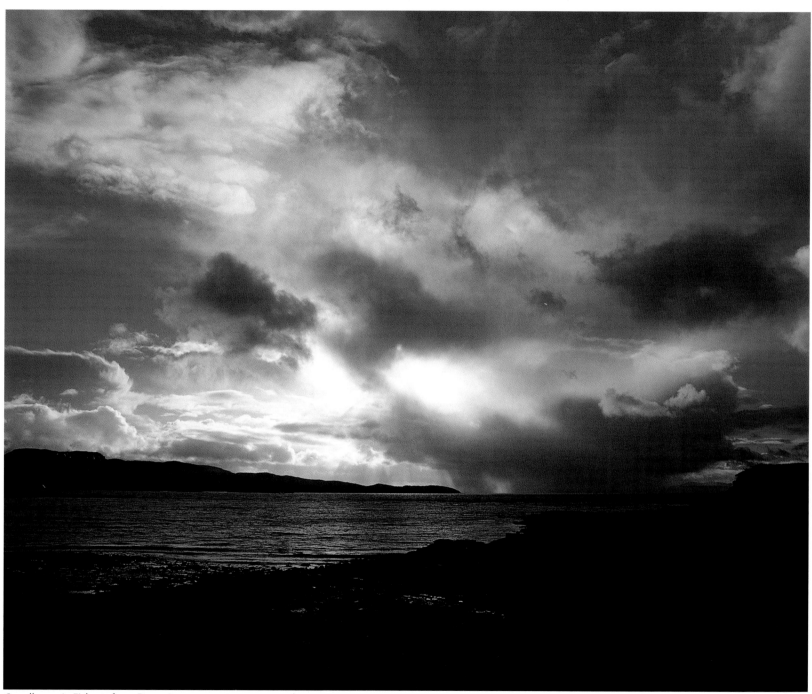

Squall over L. Eishort, from Boreraig

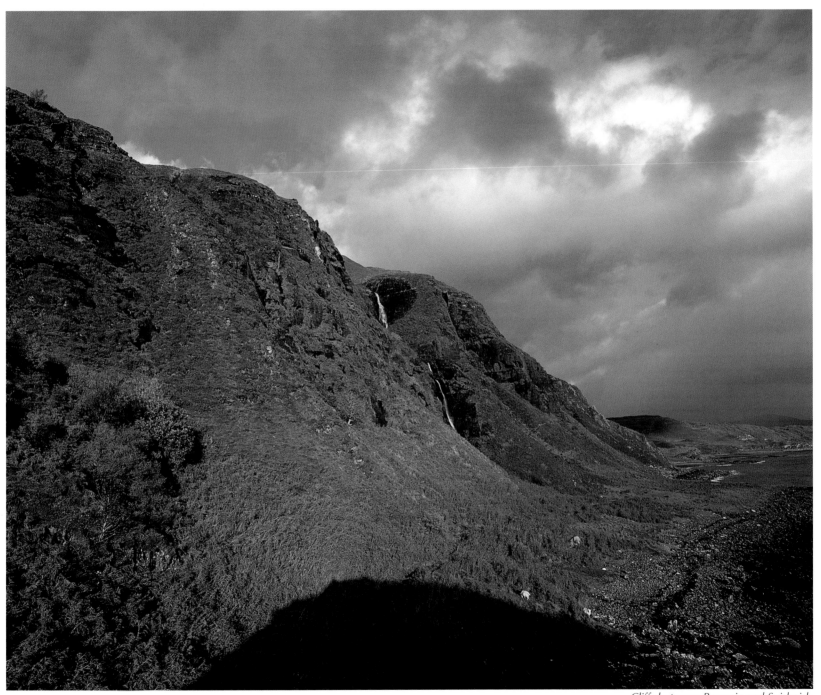

Cliffs between Boreraig and Suishnish

Abandoned cottage at Suishnish

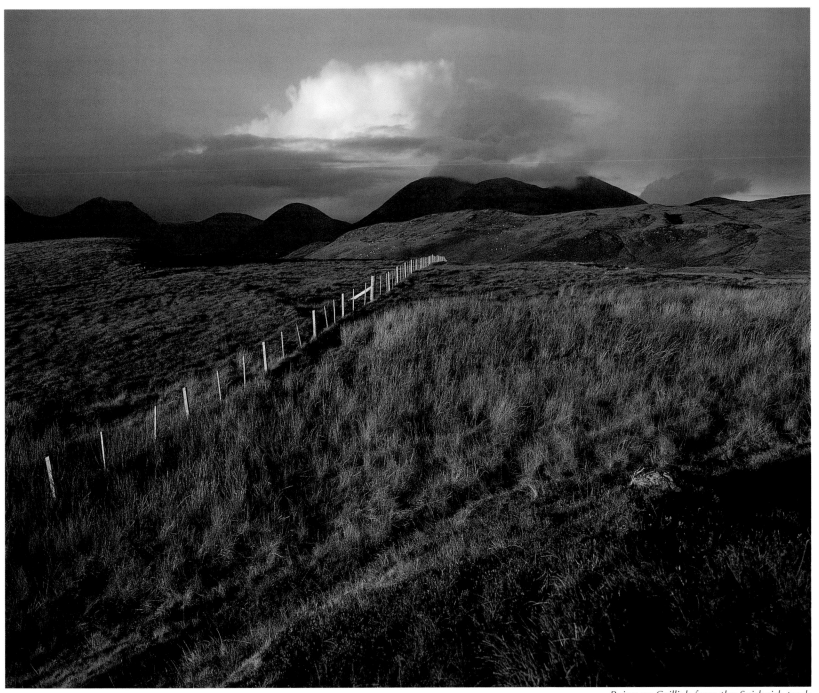

Beinn na Caillich from the Suishnish track

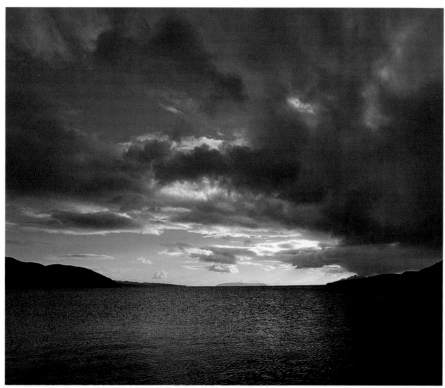

L. Slapin and Eigg from Camas Malag

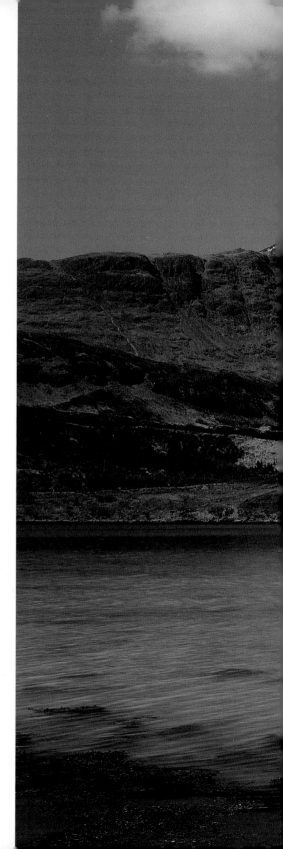

The Bla Bheinn/Clach Glas group from Torrin

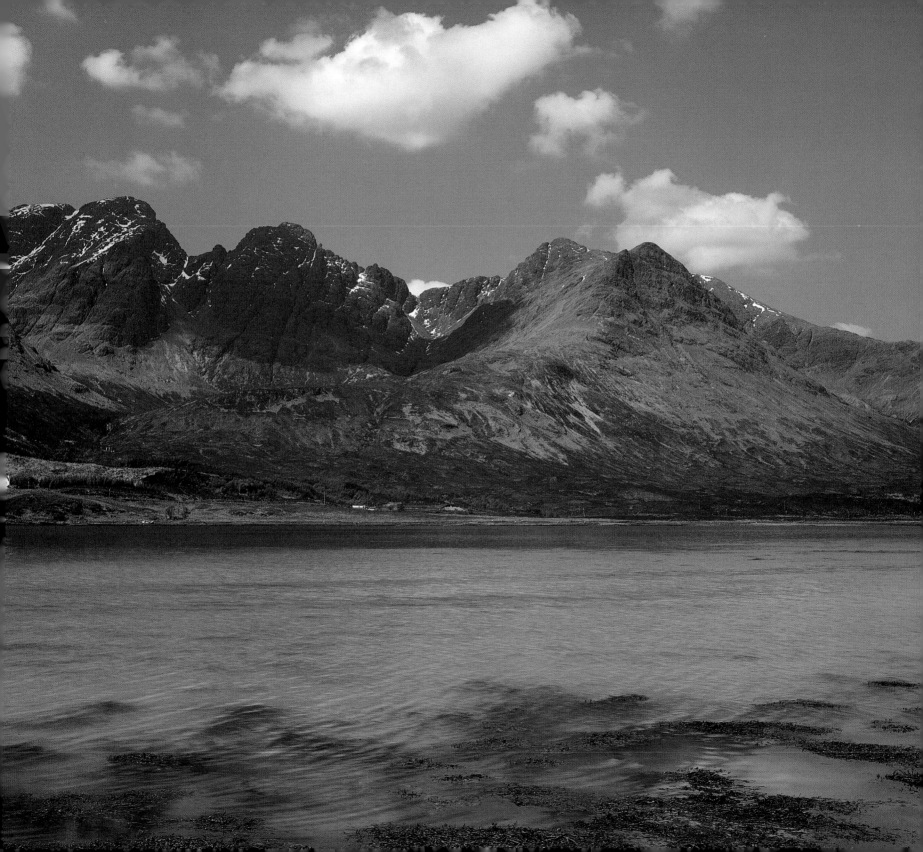

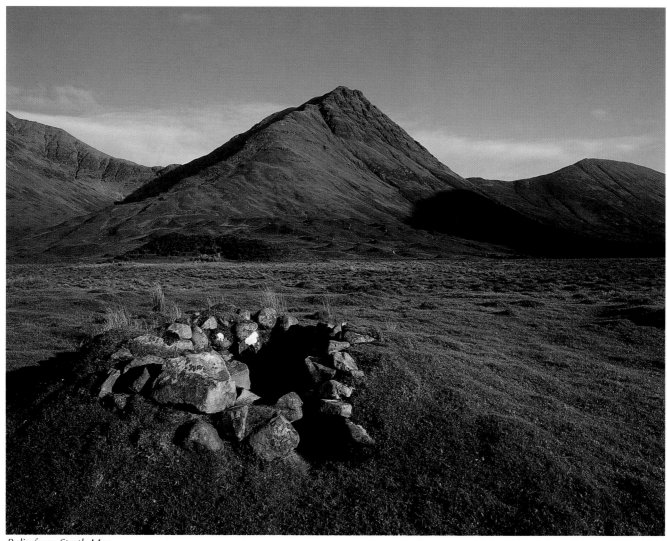

Belig from Strath Mor

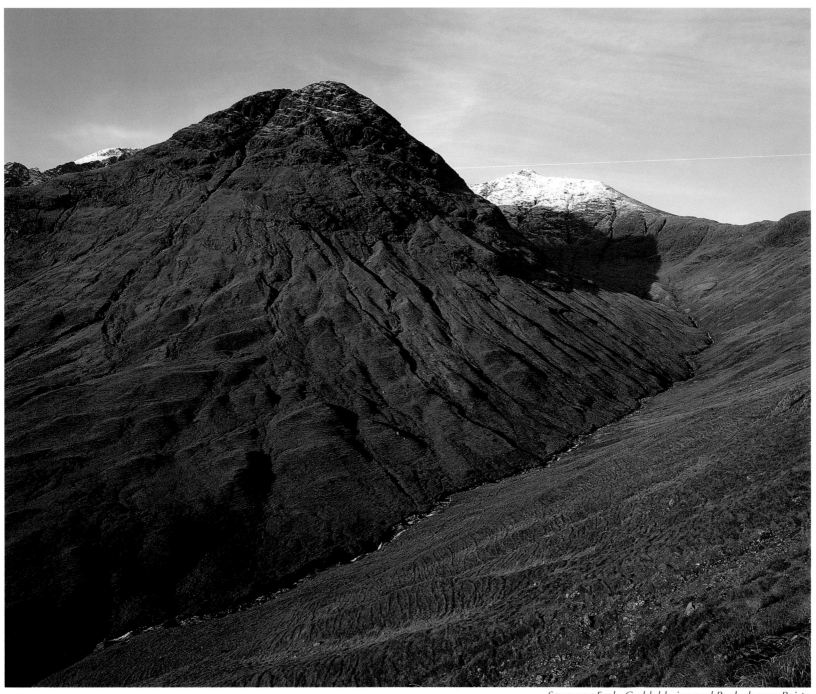

Sgurr nan Each, Garbh-bheinn and Bealach nam Beiste

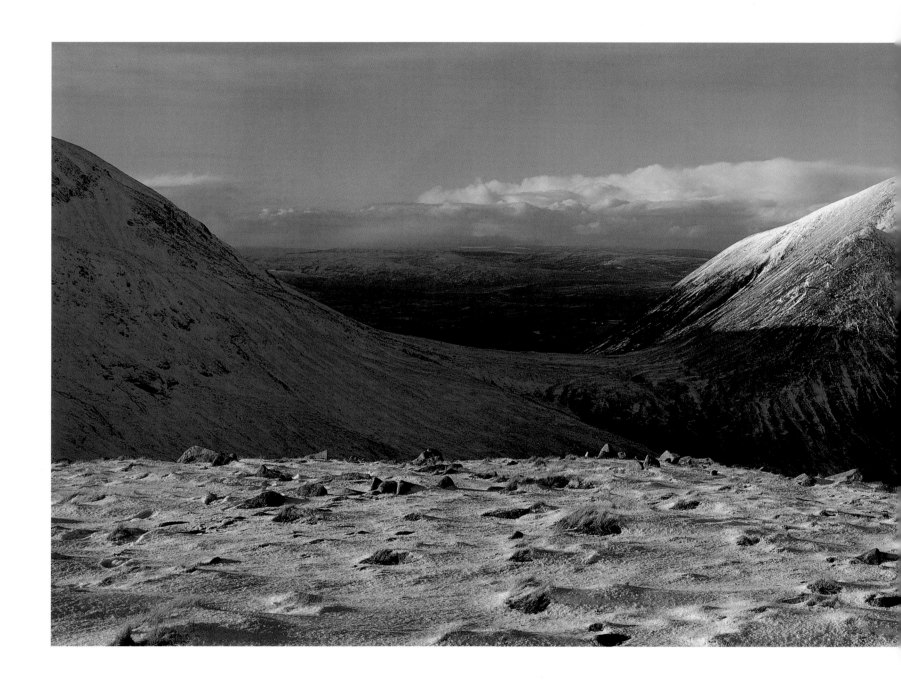

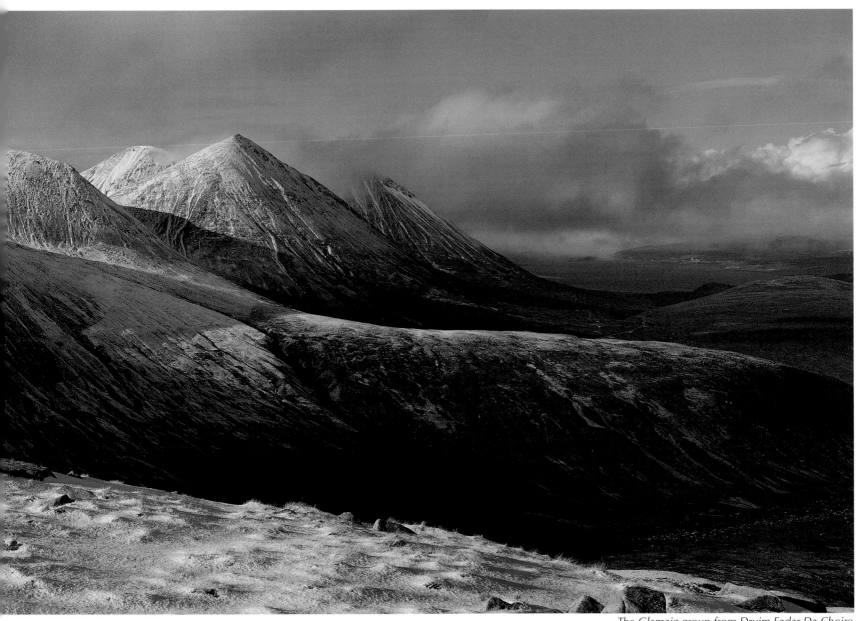

The Glamaig group from Druim Eadar Da Choire

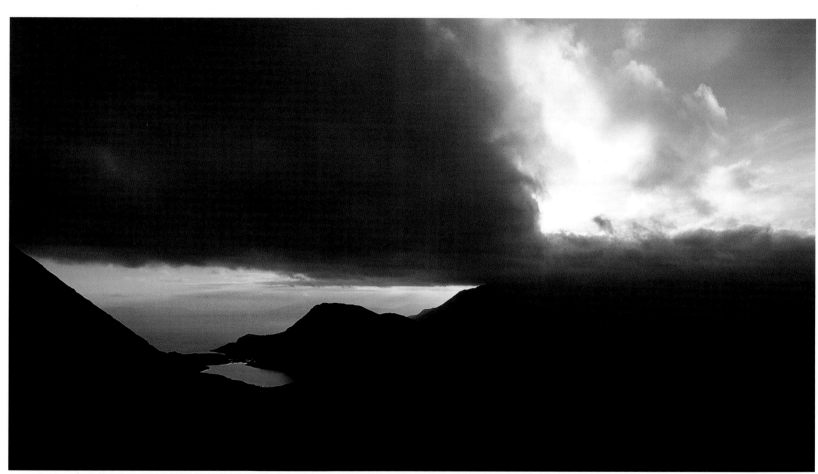

L. na Creiteach and Sgurr na Stri from Druim Eadar Da Choire

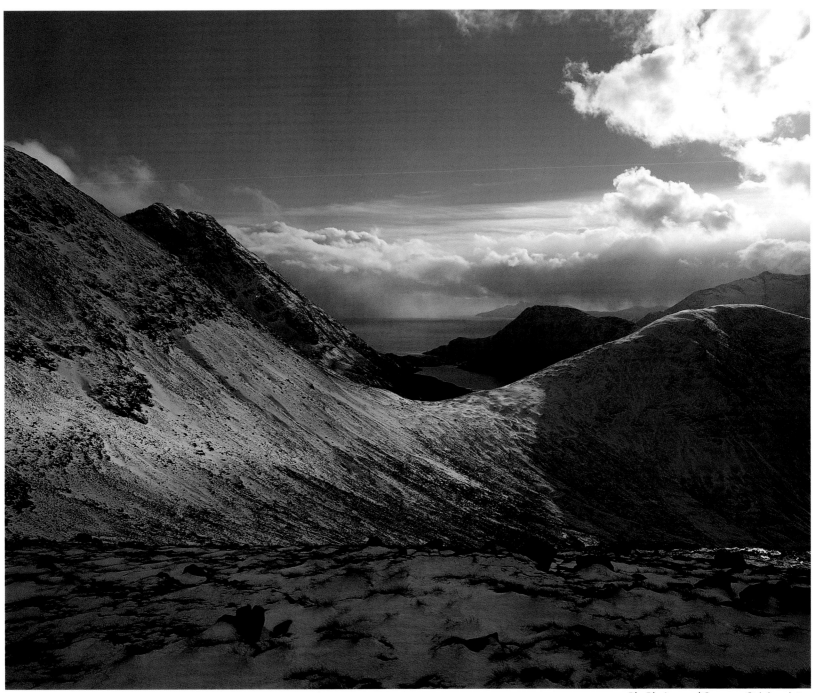

Bla Bheinn and Sgurr na Stri, in winter

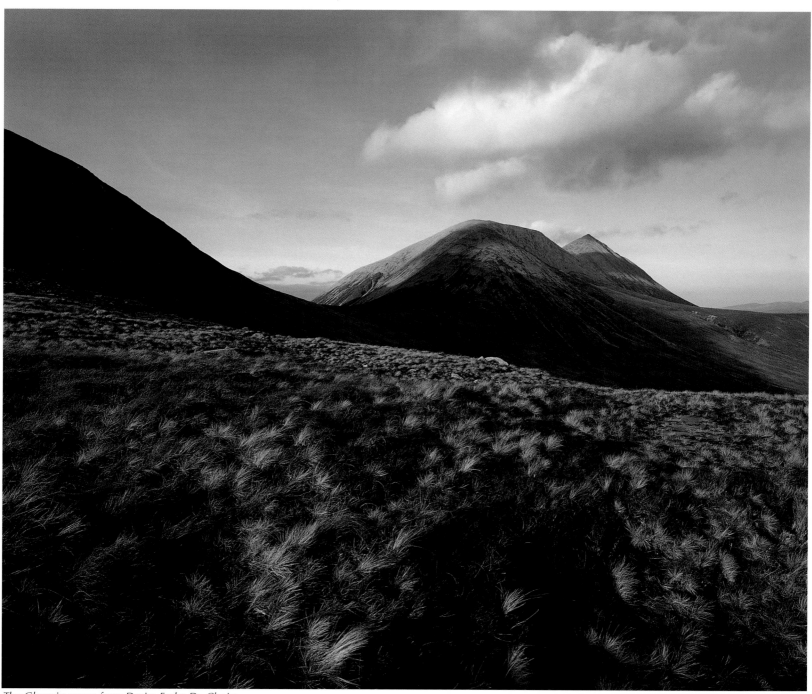

The Glamaig group from Druim Eadar Da Choire

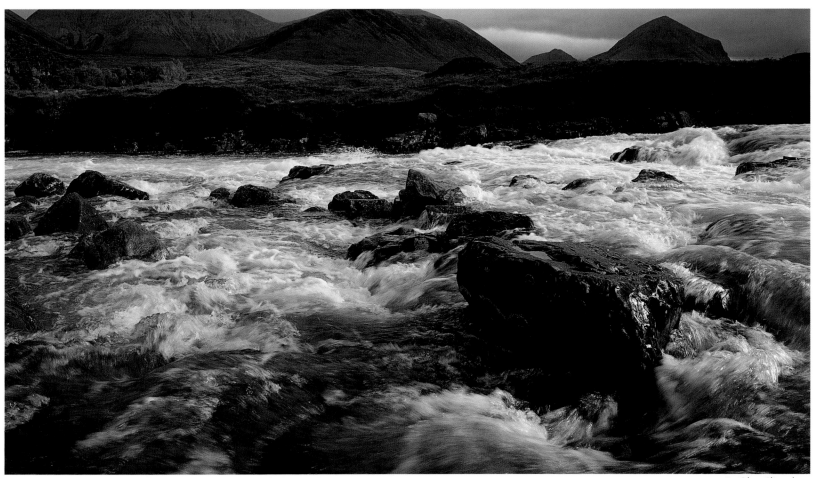

In Glen Sligachan

DAYS 5/6
SLIGACHAN - THE STORR

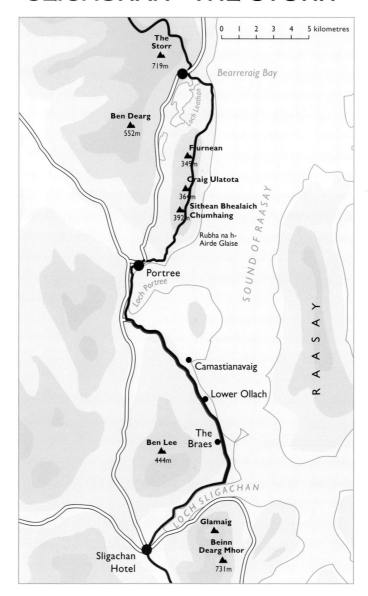

0 1 2 3 4 5 kilometres

The Storr
▲
719m

Bearreraig Bay

Ben Dearg
▲
552m

Fiurnean
▲
349m

Craig Ulatota
▲
364m

Sithean Bhealaich
▲ **Chumhaing**
392m

Rubha na h-
Airde Glaise

Loch Leathan

SOUND OF RAASAY

Portree

Loch Portree

● Camastianavaig

● Lower Ollach

The
Braes ●

Ben Lee
▲
444m

R A A S A Y

LOCH SLIGACHAN

Glamaig
▲

**Beinn
Dearg Mhor**
▲
731m

Sligachan
Hotel

DAY FIVE, AM. SLIGACHAN TO THE BRAES (7.5kms, 1/2 day, height-gain 65m). From the hotel, cross the Portree road and walk through the campsite, heading for Loch Sligachan, and making sure to keep the river always to your right. Pass a number of ruined croft-houses by a knoll and large rowan tree, and bear slightly left to pick up a good footpath which heads east along the northern shore of Loch Sligachan. This crosses innumerable small streams, and one or two larger ones, coming down the slopes of Ben Lee. Follow the footpath all the way to the first houses at Peinchorran, where it becomes a single-track road. This road is then followed all the way through the townships of

Peinchorran, Balmeanach and The Braes, as dramatic sea-views open out to the east towards Raasay and south to Scalpay, across the beach and peninsula of Camas a' Mhorbheoil. Alternatively, another slightly higher road, which avoids most of the small townships, may be used.

DAY FIVE, PM. THE BRAES TO PORTREE (10.5 kms, 1/2 day, height-gain 60m). The road continues through Gedintailor and Upper and Lower Ollach, past the junction for Camastianavaig and on across open country to the little

Grasses, R. Varragil

crossroads at Peinmore. Go straight across this junction, heading for Portree, and stay on the road until the bridge over the Varragill River has been crossed. Immediately after the bridge take a track on the left (west) bank of the river, then the west shore of the Varragill estuary (Loch Portree) all the way to the River Leasgeary on the southern outskirts of Portree. Walk up through grassy fields on the bank of the river to join the main road into the town. Portree has all the usual facilities including b&b, hotels, shops, information centre, banks and restaurants, and year-round hostels of various standards.

Leaving the hotel at Sligachan, the route is back beside the sea for a couple of days, this time on the island's east coast, and route-finding becomes straightforward again.

The early morning is bright and cold as I step out through the busy campsite east of the hotel, heading down towards the north shore of Loch Sligachan. A path leads from the south-east corner of the site out onto the river-bank and can be followed almost without a break all the way to Peinchorran; within a few hundred meters I pass the inevitable group of ruined crofts, huddled round a hillock under a single rowan tree. There is a sizeable estuary here, divided by the braids of the River Sligachan, as the tide recedes, into areas of sea-grass and mudflat. Seabirds and waders dot the estuary; a pair of oyster catchers keep up a non-stop shriek of alarm as I pass, and a group of herring gulls, sitting on a grassy islet, watch with their usual sour and hostile expression. Near the sea-loch proper, a flock of sheep, which had been dozing along the foreshore, scatter as I approach. Some potentially fine views down the loch, with Glamaig rising dramatically àlong its southern shore, are spoiled initially by several lines of large telegraph poles which cross the valley-floor, but once the path has passed beneath them the view is uninterrupted.

The OS map shows around twenty-five streams of various sizes draining the slopes of Meall Odhar Mor and Ben Lee into Loch Sligachan, and all of these have to be crossed en route to the road-end at Peinchorran. In spite of all the recent rain, however, none of them have much water, and most are no wider than a single stride; the biggest comes down from Meall Odhar Mor near the head of the loch in a noisy series of falls and cascades. The walking here is uneventful and easy after yesterday's climb through the Garbh-bheinn range and the tougher walking previously along the north coast of Sleat. It is pleasant to have a good path to follow, for a change – no need ever to wonder which way to go next, and nothing more to do than put one foot in front of the other. As a result the mind floats free, and time and distance rush by; in no time I am far down the lochside and approaching the only other large stream which comes down the hill, the Allt Garbh Mor, its gully marked by a thick line of hazels and birches descending otherwise treeless slopes. Immediately above and below the path, pretty waterfalls splash into shaded pools; the uphill stretch of the deep-cut gully looks as if it might repay a little exploration and so I dump my pack by the stepping-stones and set off up the rocky stream-bed.

Miniature waterfalls and cascades, deep quiet runs and sculpted whirlpools follow in quick succession. Above, a longer waterslide comes down steep rock hidden under a blanket of black, dripping moss, and the gully becomes a true ravine with high perpendicular walls only a meter or two apart; some hidden spectacle or extravagance is hinted at. Driven out of the gully, I take to heathery slopes east of the stream and climb until I can

force a way, partially at least, back in. Hard to see, and even harder to get near, the stream plummets nearly 100 feet (30m) in a vertical cleft concealed by a twist in the ravine-walls beneath it, and almost completely screened by dense foliage. I climb and cross the stream above the falls, trying for a better sight from the opposite bank, but this really is hidden treasure and eventually I give up the struggle. Probably the only way to approach these falls is by wading (or swimming) up the long narrow pool at their foot, and I'm not ready for that today.

The last mile to Peinchorran is a dawdle along the broad path which climbs away from the shore a little as the village is approached. Just before the first houses the path meets the road-end at a wide turning place and picnic area, and the breeze has dropped enough to let me sit here for a few minutes in midday sunshine, to examine this view of Glamaig and a fragment of the Cuillin ridge still visible back down the loch. It is tempting, but too early, to eat my meagre lunch here, and so before greed gets the upper hand I set off along the road past the first few houses.

These mostly modern, or at least modernised, cottages have a prosperous look – trim and well-maintained, with tidy gardens – but a somehow abandoned air, not of neglect, but rather as if everyone had gone on holiday. Today there is no-one to be seen or spoken with, and in moments I have reached a fork where the lower road goes through the hamlets of Balmeanach, The Braes and Gedintailor. The upper stays well above the houses and on a clear day has the better views out over the Raasay Narrows and the island itself. Along this two-kilometer stretch of single-track road I meet not a single person, nor any vehicle except an old and mouldering tractor, dead by the roadside, and at the highest point, before the road begins to drop down towards Gedintailor I seek out a sheltered spot with a good outlook, to sit again for a while. Out beyond the white-caps being driven through the narrows by the constant north wind, the little peak of Dun Caan raises its unmistakable profile against a sky of palest blue. The cap of a long-extinct volcano, this plug of hard, black basalt remains after all the softer rocks around were planed away by glaciers, and is uncannily volcano-shaped, its tilted cone one of the most familiar landmarks along the western seaboard of the Highlands. North, up the coast of Skye, the complex outline of Ben Tianavaig, falling in a series of uneven terraces and steep short crags to the sea, is a harbinger of stranger hills to come.

These scattered villages, known collectively as The Braes, are famous for two very good reasons. Perhaps the better-known is that this was the site of the last battle fought on British soil, and at the road-side above Gedintailor the inscription on a memorial cairn gives the date and the barest outline of the story. The other source of The Braes' fame is that for many years, until his death in 1996, it was the home of the greatest Gaelic poet of the 20th century and a towering figure in Scottish literature, Sorley MacLean.

The battle was fought in 1882 between local crofters and a force of sixty police brought from Glasgow and Portree. The people had been protesting about unfair treatment, summary evictions and confiscation of common grazing rights and for once were not inclined to be silent or docile in the face of an authority for which they had lost all respect. When the police came to remove those they regarded as ringleaders they were violently resisted, and the resulting battle claimed numerous casualties on both sides, though fortunately no deaths. The police succeeded, however, in arresting and taking away their five main targets who were tried, convicted and fined in Inverness Sheriff Court. Their fines were quickly paid by well-wishers and the five men returned as heroes to their friends and families. This skirmish was only the latest, if the most serious, in a series of such protests on Skye, and warships were despatched to patrol the island's waters and troops landed to cow the people into submission. However someone in Government perceived that a real injustice was at the heart of these troubles, and the next year a Royal Commission was set up to enquire into the plight of the crofters. By 1886 they had been granted security of tenure and the right to pay only a fair rent, set by outside Commissioners. It had taken over a hundred years of cruelty, mass evictions and rack-renting to shift the crofters from their docility and traditional deference to authority, and though estate-owners and landlords still wield enormous power even today, things in the Highlands were never quite the same after The Battle of The Braes.

Sorley Maclean's forebears came from Skye and Raasay, and he was born and brought up at Ostaig, on Raasay. His great-grandfather was evicted more than once from townships on Raasay, and though the range of his poetry includes war verses from World War II, it is as a chronicler of the long suffering of the Gaelic people that he is best known. His collection of poems published in 1943 has been compared in stature to T.S. Eliot's *The Waste Land*, and though he wrote mainly in Gaelic, his poems about his island – *Hallaig*, *The Woods of Raasay*, and *Screapadal* – are both magical and almost unbearably moving, even in translation.

The island he loved and wrote about is slowly disappearing in a growing haze as I tick off the names of the townships along the road – Upper Ollach, Lower Ollach, Achnahannait, Conordan, and Camastianavaig lying in its hollow underneath the Ben. At times a dip in the road will hide Raasay briefly from view, and each time it reappears the island has receded a little further into the greying distance, its outlines vaguer, slipping away in time and space. This morning Dun Caan was etched in a hard blue light, by midday the sky was like milk, and now a soft afternoon haze has melted the little peak away to just a shadow. As I follow the road across the open moor beyond the turn for Camastianavaig, Raasay finally disappears, hidden behind the hill, vanished in the mist.

The road drops down to Peinmore, and drops

again through trees to the bridge across the River Varragill. A nearby swathe of conifer woodland has been clear-cut very recently; the air is heavy with pine-resin and the cleared area is a wilderness of stumps and stripped branches. Just across the bridge a metal gate opens onto a broad path along the river-bank, which heads north towards Portree. I plunge down and along it, through head-high whin and broom, with the river hidden for a time behind thick undergrowth. The Braes road made easy walking, but it is good to feel turf underfoot again, the shingle of the river's wide flood-course or stepping-stones across a sidestream.

The tide is far out now, and the estuary is a wasteland of grey stones and mud – plaintive cries from some distant birds – and the hills and head-lands beyond Portree are lost in a fume, like Raasay. There is a hum of traffic from the main road, just two hundred meters above the shore, but it is far enough away to be ignored, and this path along the grassy foreshore is infinitely better than jousting with the cars along the A850. The thick grass (no sheep grazing here) begins to alter-nate with slick, black rocks; some houses appear above the foreshore, then it's all rock underfoot in a narrow gap between garden walls and muddy beach. The shore opens out again – here is Portree's river – I turn a corner by a wrecked boat, walk up through a field to the road and in a few minutes am in the centre of the town.

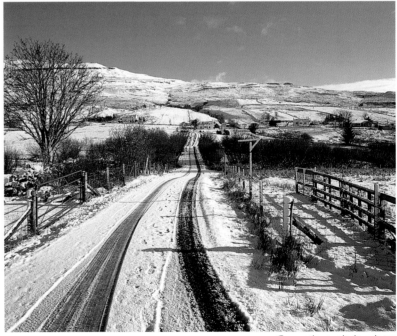

Camastianavaig in winter

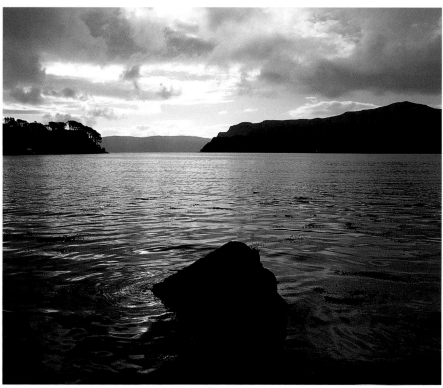

Loch Portree

DAY SIX, PORTREE TO THE STORR (12.5 kms, easy day, height-gain 560m). From the centre of Portree, begin by heading north out of town on the Staffin road until a minor road sign-posted "Coulin View Hotel" drops down towards the north shore of Loch Portree. Take this road until it ends at a slipway, then follow the good footpath which continues along the shore, and round under the thickly wooded headland of Ben Chracaig. This area is a park dedicated to the people of Clan MacNichol who were cleared from around here in the 19th century. When the fields of Torvaig come into view, cross a drystone dyke by stone steps.

Climb a little, heading north, following an ancient boundary wall now thickly grassed over, until a stile over a fence leads out onto open slopes above. Climb steeply up, keeping the cliff-edge a safe distance away to your right, and head directly to Point 392, another kilometer away to the north. This is the first of several high points along these cliffs which must be climbed – Sithean Bealaich Chumhaing, Craig Ulatota and Fiurnean – before they begin to trend downwards towards distant Bearreraig. The cliff-edge is followed continuously all the way past Holm Island, until Bearreraig Bay, and a sketchy footpath, appear. Before

Wild rose, Ben Chracaig

this, two lines of low crags running west have to be descended; these pose no problems, however, and are easily threaded by open grassy gullies. From the two Electricity Board buildings at Bearreraig a good single-track road runs back west along the shores of Loch Leathan. Follow this until grassy slopes can be climbed, round the corner of a plantation of conifers, up to the main Portree to Staffin road immediately below The Storr. Bearreraig Cottage, where b&b is usually available in summer, is two hundred meters back towards Portree.

As I planned the route, today's walk is short; there is no need to be away at the crack of dawn, and plenty of time to enjoy a few of the town's facilities – to browse the shops for new reading material, and then relax for half-an-hour over a coffee with the daily papers.

Loch Portree is a boat-haven; pleasure-craft of all kinds and an inshore rescue vessel lie at moorings; work-boats come and go. The little road around the north shore passes what seem to me some of Portree's most desirable properties, but soon ends at a slipway, from where a path continues through the Clan MacNichol memorial park. The vegetation is luxuriant under the protecting slopes of Ben Chracaig which forms the bold headland at the mouth of the loch. There are wild roses here of every shade from palest pink to deep magenta, a thick tangle of bramble bushes, wild raspberry and crab-apple, and those faithful companions found in every highland wood – hazel, birch and rowan. As the path rounds the headland, several large rafts of salmon-farming pens come into view and the north wind, which has been on the increase all week, strikes for the first time today with a cold bluster. Out at the salmon-pens dark heads slip through the water – seals are drawn to the caged fish – but as I stop to watch, the size and playfulness of these two creatures reveal them as otters. They are far enough offshore not to be bothered by me, and after a leisurely examination of the cages, swim off to a more distant raft. This is my third otter sighting since the start of the walk, and there is no animal which gives me more pleasure to see. Not only are they beautiful and appealing creatures in themselves but it seems likely that an environment which sustains increasing otter numbers must itself be reasonably healthy.

Beyond Ben Chracaig the green slopes of Torvaig come into view, and I follow a high dry-stone dyke round to the left and away from the shore until a stile appears. Above the lowest fields a path cuts through an area of rough pasture then follows an ancient boundary wall, hidden under turf but as massive as a defence-work – it puts me in mind of Offa's Dyke along the Welsh Marches – then down to a fence and stile. A high grassy bank leads steeply upwards, and keeping the cliff-edge off to my right I head for a flat area behind the cliffs called Bealach Cumhang, "The Narrow Pass" (between cliff-edge and hilltop), on the OS map. As I climb, stunning views open out under an immense sky, back down the coast past Ben Tianavaig to Raasay and the narrows, Scalpay, and the hills of southern Skye. Ahead there is no path to speak of, but innumerable sheep-trails; the firm turf everywhere is close-cropped so that walking is pleasurable and the clifftops lead inexorably to the highest point of the day, Sithean Bealaich Chumhaing, from whose summit 1250-foot (390m) cliffs and steep grass slopes drop directly into the sea.

Northwards, the crags are split in two by a long terrace, and shortly after dropping down from the summit it is possible to descend on to the terrace which could then be followed for the next three

kilometers. I prefer to keep to the higher line above the upper crags, however, for the sake of the views, which are open in every direction.

Soon there is a longish pull up and over another top, Craig Ulatota, and beyond it the clifftop leads on, roughly level, swelling only slightly over the next and last high point, Fiurnean. The entire sky has been covered quickly today with a film of high cloud, and the wind is full in my face all the way, coming in strong gusts and cold enough to make me gasp when it hits. Aware of danger from this buffeting, I keep well back from the edge and plod on, frustrated that yet again flat light and dull conditions are going to prevent me getting any useful photographs. From here the southern tops of the Trotternish Ridge form the western horizon, and The Storr presents its usual extravagant profile but masks all the northern continuation of the ridge; I will be up there this time tomorrow. The coast of Skye, and the broad Sound of Raasay fade off into grey distance; eastwards, Rona and Raasay lie like dark shadows on the surface of the sea. Coming down off Fiurnean there is a line of crags which has to be threaded, but a wide shallow gully makes this very easy; a little further on, another line of low crags swings away west across my path but these, too, present no difficulties. Underfoot the ground has become softer, the heather and sphagnum deeper and spongier as I progress north, and together with the strong wind this makes for tiring conditions. I peer at the map a moment, hoping there is less work to be done than looking up the

coast would indicate; but it is still nearly three kilometers to the power-station at Bearreraig, where I will pick up the single-track road around Loch Leathan. The day is gloomier than ever. I stumble on towards the gentle incline which will lead to the top of the high sea-cliff called Holm, whose calf, Holm Island, lies close inshore. On the uphill stretch, just as I am beginning to feel a trifle sorry for myself, a lark flies out from right beneath my descending boot. She had lain so very tight, to the last possible moment, that there must be a nest, and I step back a little and look carefully where I had been about to tread. Gently parting the grass and heather fronds, I find the nest far down beneath their surface, hidden from predators and these biting winds, lovingly lined with soft grasses, sheeps' wool, and dark hair which can only come from deer; in the centre of the cup, five brown-speckled eggs of the very palest green. It is so perfect that the smile comes back immediately to my face and stays, at least in my mind, all the way down to Loch Leathan.

On the loch, tethered rowing-boats bob near the shore, straining in the wind against their lines, and a large green-painted shed – probably their winter quarters – gives me some shelter to sit and eat a bite. It was far too cold and exposed to want to stop or rest or eat anywhere along the clifftops, but now though I am only a kilometer from the end of today's stint, it is good to pause and get out of the firing-line. It is still only mid-afternoon. I look south across the loch at the way I have come, back

across the brown rolling moors to Portree; at the limits of vision the Cuillins are just perceptible through the haze, and seem very far away. Strange to think that only two days ago I was there. Once back on the little road I follow it only until it turns too much south for my liking, then cut uphill to the right away from it, sheltered by a conifer plantation whose edge I follow. The main road soon comes in sight; then The Storr carpark; then finally Bearreraig Cottage itself.

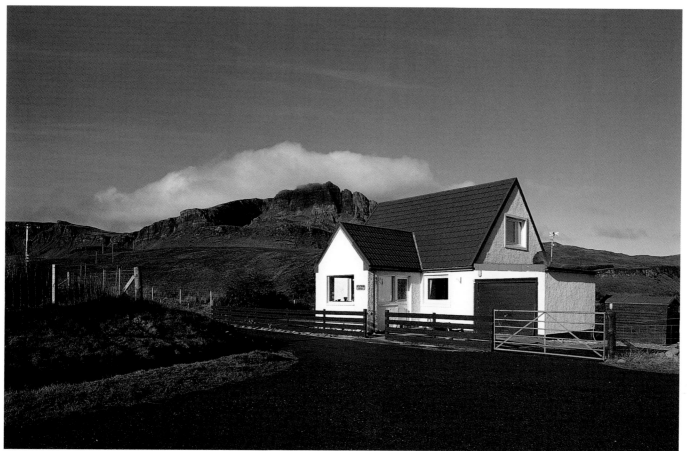

Electricity Board house at Bearreraig Bay, and The Storr

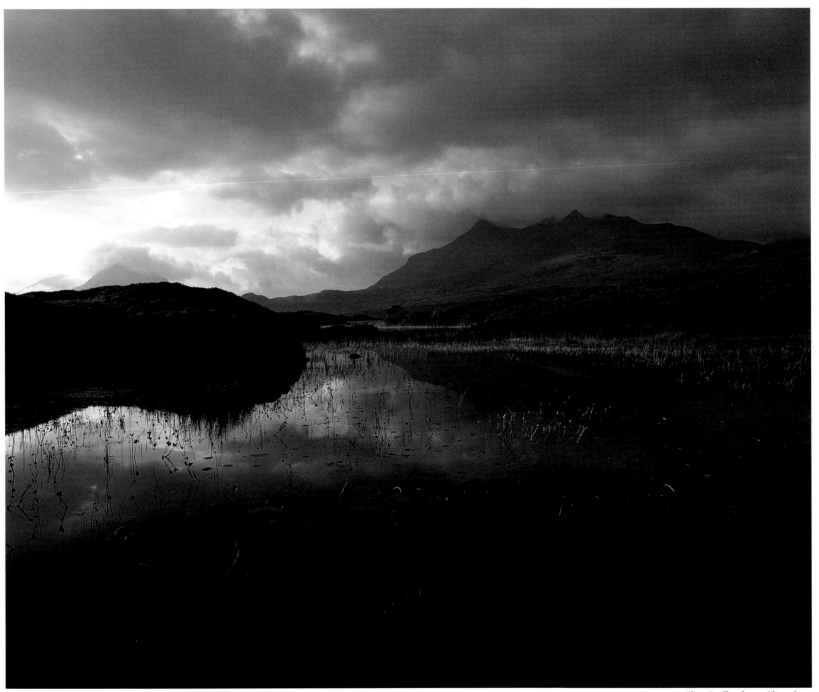

The Cuillin from Sligachan

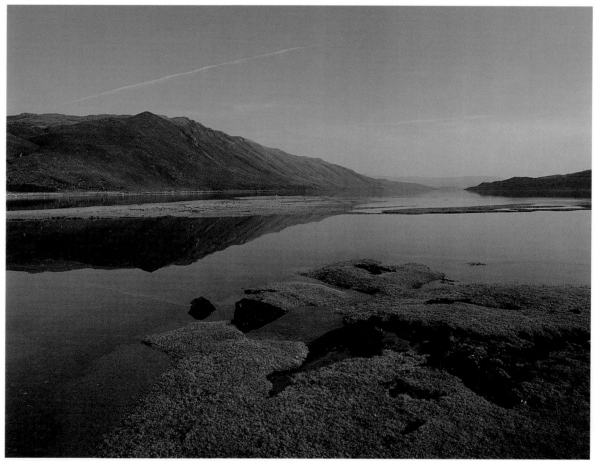

Loch Sligachan from the west

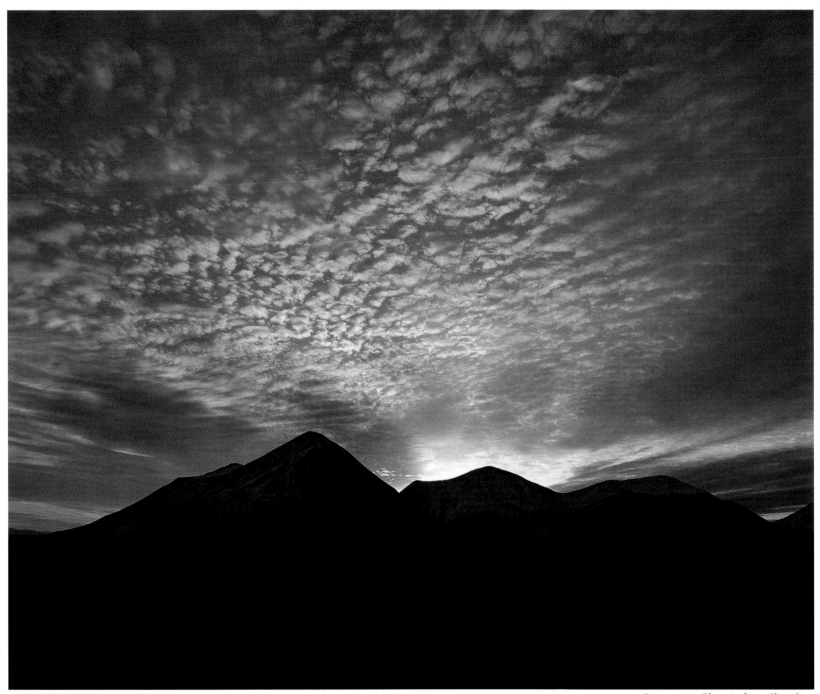

Dawn over Glamaig from Sligachan

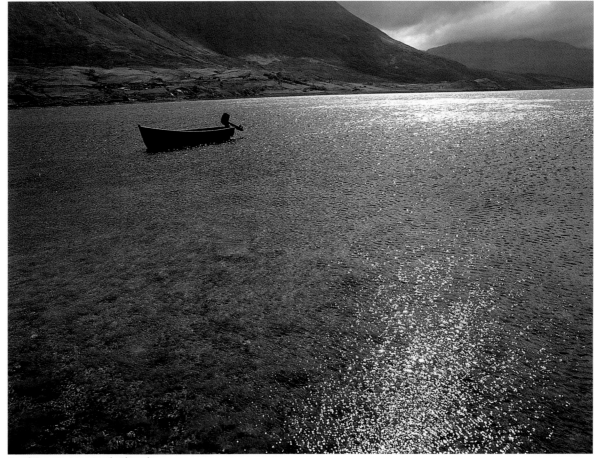

Looking west up Loch Sligachan

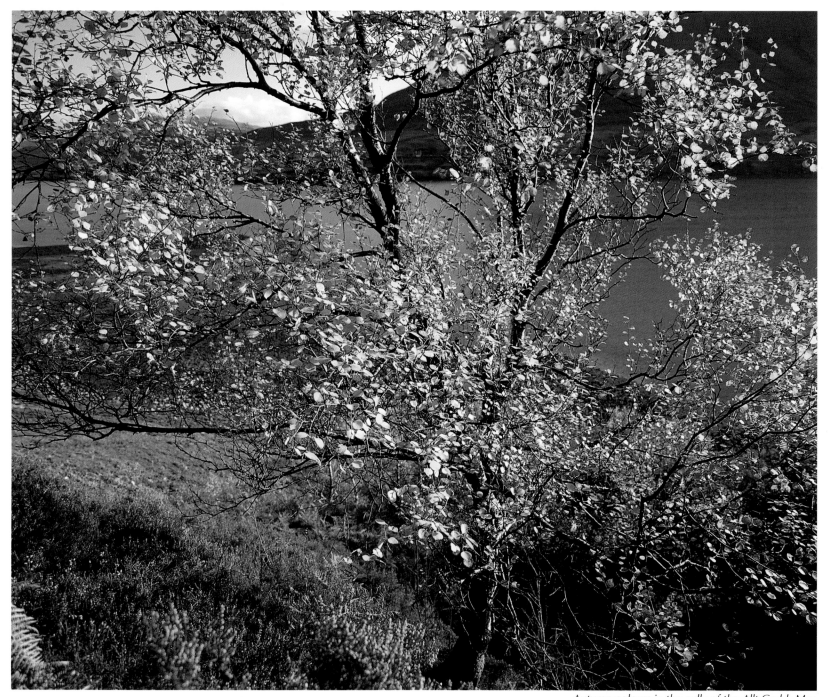

Autumn colours in the gully of the Allt Garbh Mor

Dawn over Raasay, from above The Braes

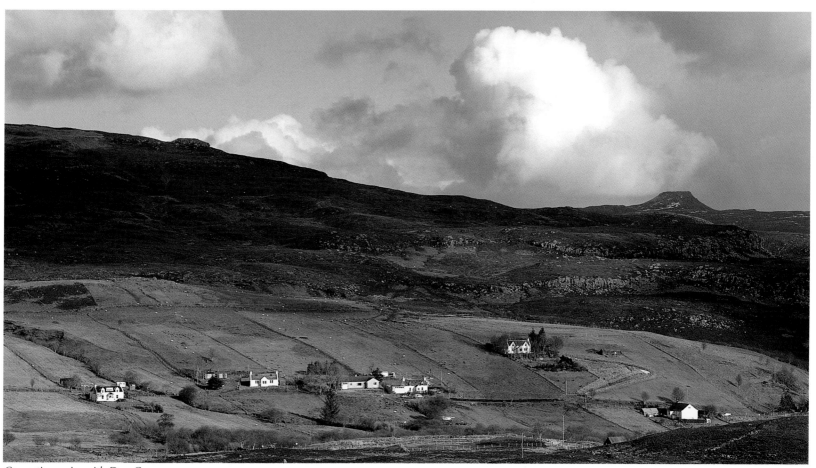

Camastianavaig, with Dun Caan

Portree harbour, dawn

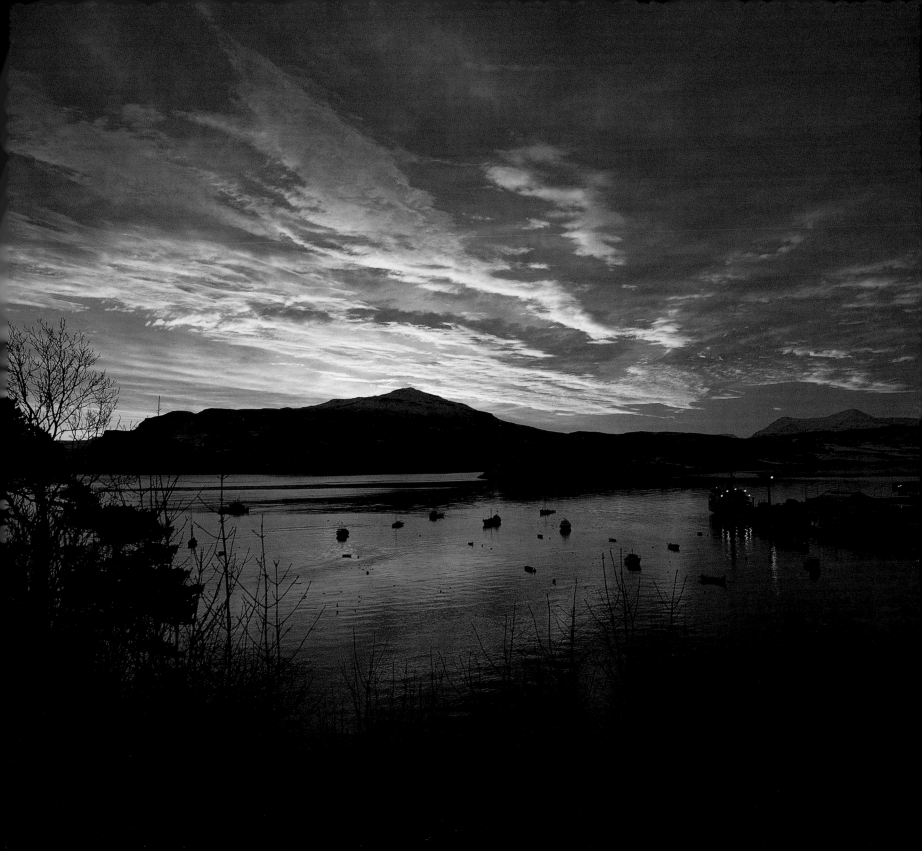

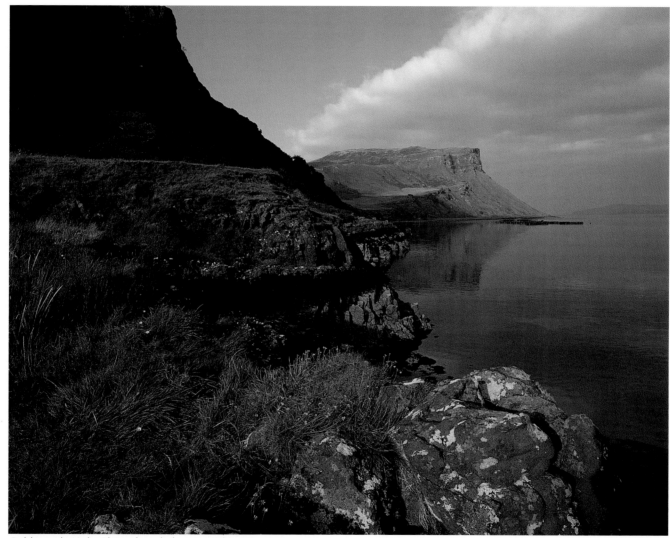

Rubha na h-Airde Glaise, from below Ben Chracaig

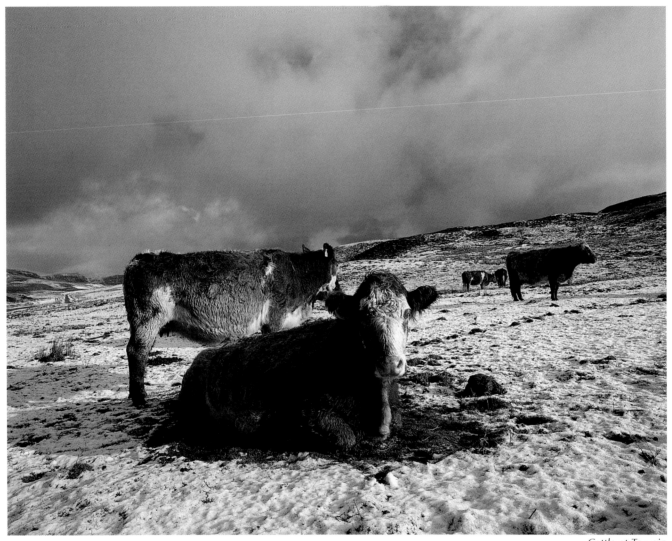

Cattle at Torvaig

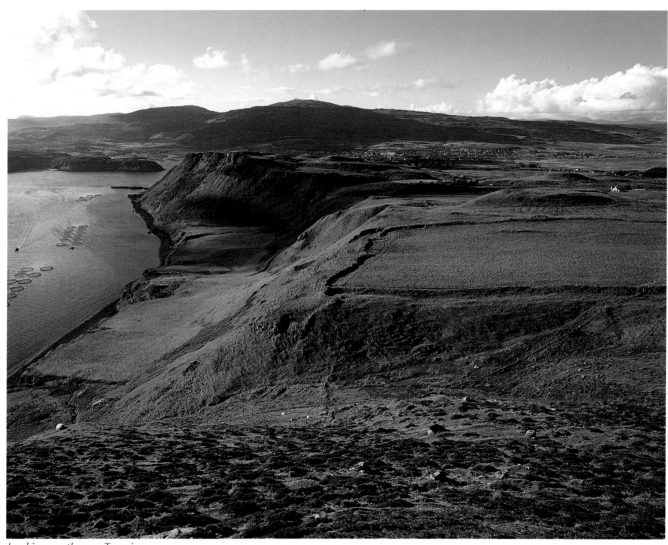

Looking south over Torvaig

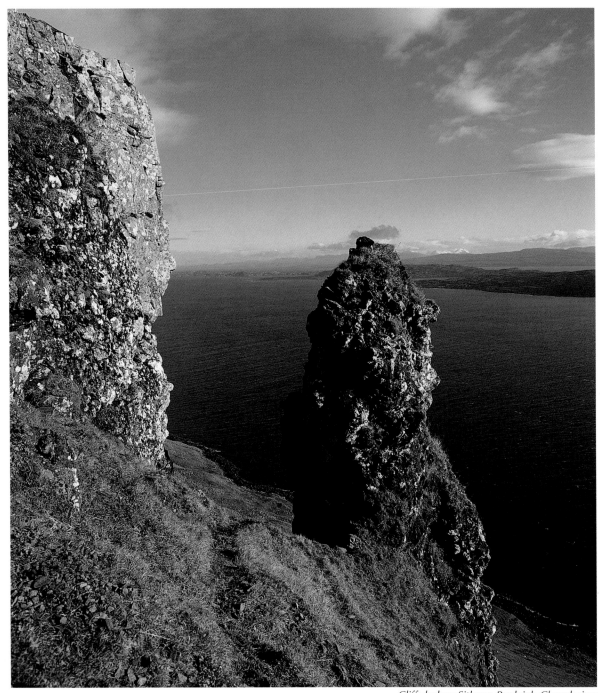

Cliffs below Sithean Bealaich Chumhaing

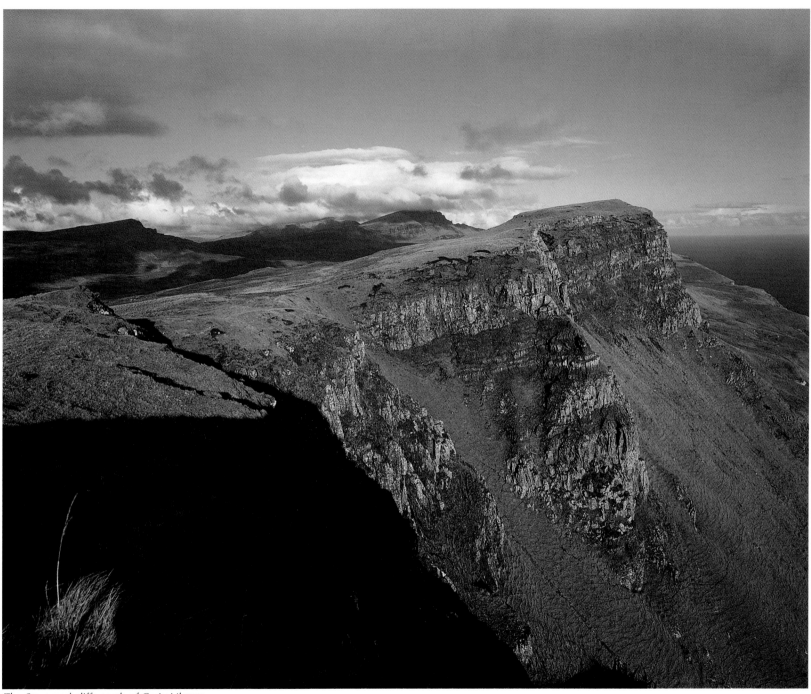

The Storr, and cliffs north of Craig Ulatota

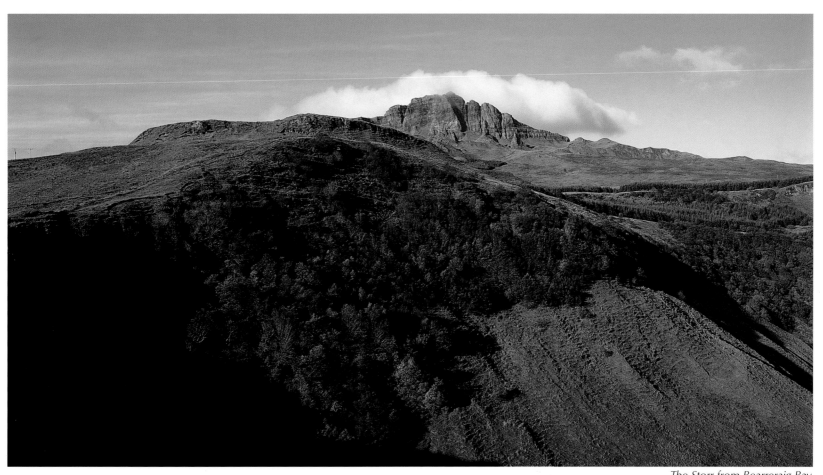

The Storr from Bearreraig Bay

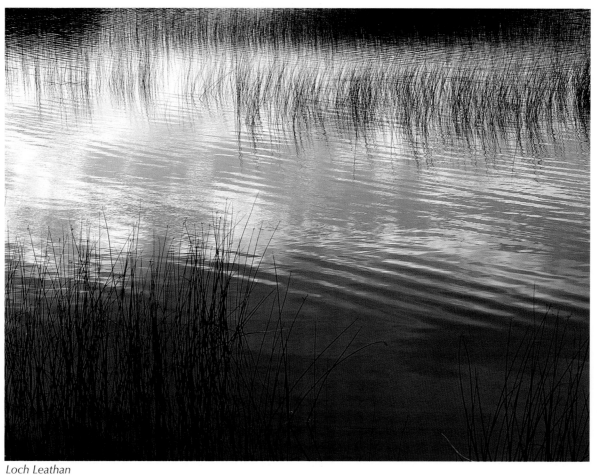

Loch Leathan

The Storr from the Staffin road

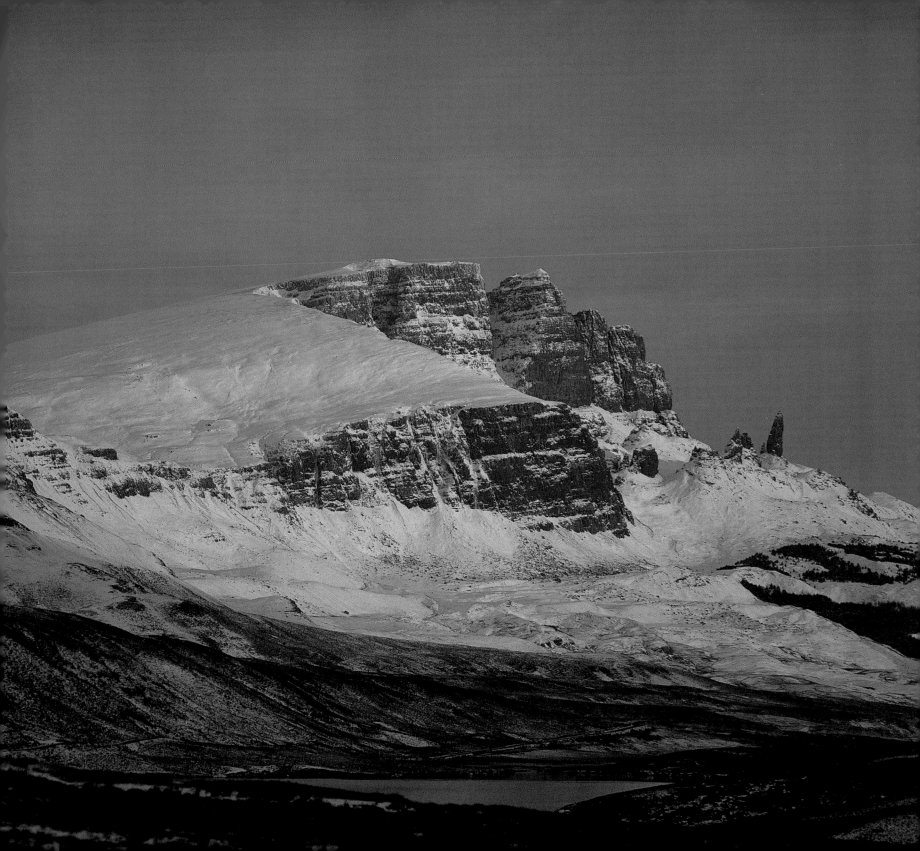

DAYS 7/8 THE STORR - DUNTULM

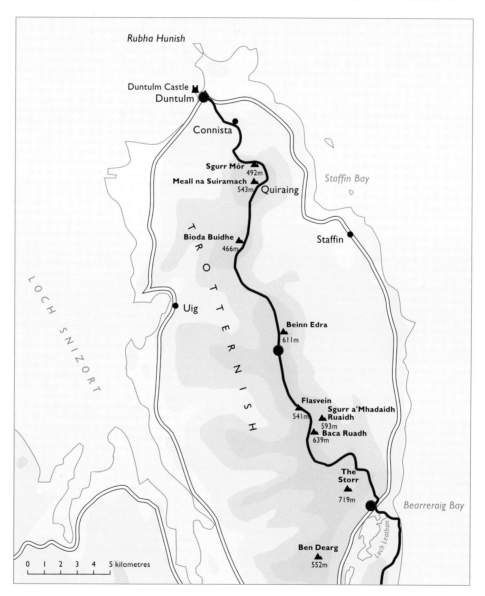

Rubha Hunish

Duntulm Castle
Duntulm

Connista

Sgurr Mór
492m
Meall na Suiramach
543m Quiraing

Staffin Bay

Bioda Buidhe
466m

Staffin

T
R
O
T
T
E
R
N
I
S
H

LOCH SNIZORT

Uig

Beinn Edra
611m

Flasvein
541m **Sgurr a'Mhadaidh**
Ruaidh
593m
Baca Ruadh
639m

The Storr
719m

Bearreraig Bay

Loch Leathan

Ben Dearg
552m

0 1 2 3 4 5 kilometres

DAY SEVEN, AM. THE STORR TO BEINN EDRA (13.5kms, long 1/2 day, height-gain 920m). A large plantation lies between the main road and The Storr, with a carpark at its southern edge. Take the tourist path from here up through the trees to the pinnacles of The Storr, turning right past the Old Man and his daughters and continuing nearly due north as far as the path goes, below steep slopes topped by high black cliffs on the left. The path finally turns a rocky corner into a higher corrie (Coire Scamadal) with another line of crags along its upper edge. Head for where these crags dip and merge into grassy slopes, and easily thread them at the north end of the corrie to emerge onto a plateau with an isolated rock island at it centre. From here, a long section of the Trotternish Ridge can be seen running away to the north. Descend open slopes westwards one kilometer to Bealach a' Chuirn and ascend, keeping close to the cliff-edge, to the summit

of Hartaval. From Hartaval, the ridge-line is followed, via several other tops, all the way to Beinn Edra, the highest summit between Hartaval and The Quirang. There are no difficulties at all, but it is important to keep the cliff-edge a safe distance to your right.

DAY SEVEN, PM. BEINN EDRA TO THE QUIRANG ROAD (7kms, short 1/2 day, height-gain 160m). From Beinn Edra the clifftops are followed northwards as before, beginning with a lengthy descent to Bealach Uige (from where a footpath descends via Glen Conon to the village of Uig, visible 6 kilometers away to the west). There is a stiff

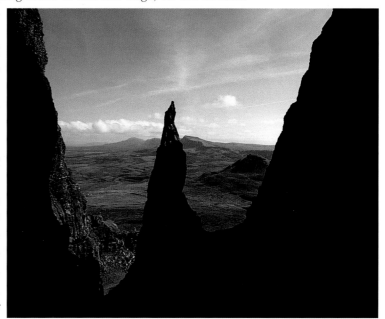

The Needle, Quirang

climb up to the top of Bioda Buidhe, the last summit before the road, now visible to the north. Another long, easy descent over heather slopes leads to the popular carpark (used mainly in summer by walkers exploring the Quirang) at the top of the pass on the spectacular Staffin to Uig road.

Early morning beneath The Storr. In the Highlands in spring and summer you must rise early if you want dawn light. (And I do!) Today the eastern horizon is swathed in white cumulus though there is blue straight overhead, and when the sun finally climbs above the cloud-band it comes with a hard white glare instead of the softer tones and colours I hope for. But at least, at this hour, the normally busy road is empty and the car-park deserted as I swing a rucksack over my shoulder and start up the track towards the hill.

The Old Man of Storr is the most prominent, and best known, of a series of exotic rock-formations beneath the main cliffs of the mountain called The Storr, and the path up to The Old Man climbs through a plantation of young, perhaps half-grown, spruce. Their tops sway in the stiff northern breeze, my constant companion on this walk. In May, the early morning can still be cold, and I am grateful for any shelter from this wind which comes sighing through the branches. (I am wondering what it will be like along the ridge, four hundred meters higher, and down here even the birds are sheltering from the cold. Their songs are all around, but they stay deep in the trees.) The trees are too tall, and the path is too tight under The Storr to see much of it, but as I gain height there are Dolomitic views out across tree-tops to the long high scarp which runs away south towards Beinn Dearg. Finally the trees drop away beneath me, and in a few minutes more I am ushered into the presence of The Old Man and his daughters,

though that is not quite how I think of this place. To me, this is The Hall of The Mountain King, and Grieg's music is always playing in my head whenever I am here. A jagged formation of stacs and pinnacles looms like the prow of some fantastic ship, and behind, the main cliff of The Storr rises over 800 feet (250m); vertical, dripping with water, black, unforgiving, terrifying. I give silent thanks that I am not here with some eager rock-athlete to try to climb it. Contained below the cliff – a sort of corrie, undulating, grass-floored, with outcrops everywhere, and bristling with rock-spires, stacs and obelisks, for The Old Man is not alone.

But he is ultimately the most impressive, and certainly the rudest; I circle the corrie slowly and pull away up a trail which heads north-east past the pinnacles, as ravens glide from cliff to cliff and croak throatily overhead, shadowing me out of their domain. Beyond all the most extraordinary rock-features the path turns a corner into an upper corrie, Coire Scamadal, and from here it is possible to look back over all the pinnacles, and see them in a truer perspective. The Old Man on his pedestal rises clear above the others, in all his priapic glory. In another two or three steps they disappear from sight as I slip through a rocky doorway into Coire Scamadal and begin to look for my way ahead.

The triangular floor of the corrie tilts sharply seawards, crags form a continuous rampart along its upper edge and more cliffs drop from its eastern and northern rim. It seems as if I have found the only entrance into it from below; now I ascend

steadily up to the corrie's northern corner where the crags reduce in height, looking for and finding an exit where they finally submerge under grassy slopes. Round the corner a large rock island – an African 'kopje' – stands in the centre of a green alpine meadow, and now I see the great length of the Trotternish ridge striding away to the north. A deep hollow to my left, Bealach a' Chuirn, leads to the great flat-top of Hartaval; beyond it is the turreted castle of Sgurr a' Mhadaidh Ruaidh; the blunt wedge of distant Beinn Edra is cloud-capped, and impossibly far away a tuft of mist hangs around the cliffs of the Quirang, my destination for tonight. Striding down to the bealach, I cross a sphagnum-filled watercourse, an island of emerald in a sea of grey rock, and heather still in winter drab.

The route from here is pre-ordained and for the next sixteen kilometers the edge of the long escarpment will be my only guide, abandoned just once to cut across behind the crenellations of Sgurr a' Mhadaidh Ruaidh and shorten the journey by five or ten minutes. The wind, which is bitter, has risen and swung easterly and I no longer have it in my face, but it rips through the bealachs, buffeting me sideways. On higher ground it is baffled by the cliffs so that if I stay just ten meters back from the edge I am in still air. Underfoot, most of the way is on firm turf – that best of all surfaces for walking – but there are large patches of bare earth from time to time; scattered rocks; and if I stray too far away from the edge, the ground degenerates into a spongy mix of deep heather and mosses.

The hills, so abrupt on their eastern faces, descend as long slow swales to the west, sinking almost imperceptibly into distant valleys dotted sometimes with farms and conifer plantations. All morning the atmosphere is clear and distant views are possible, but cloud and mist form and dissipate around the tops so that I never know if I will have a view from the next summit or be lost in white-out, and in the end I get my share of both. From time to time I am inspected by more ravens – colleagues, I feel sure, of the pair which saw me off their territory at The Storr, and once, creeping to the edge of a steep section of the main cliff, to look over, I find myself staring at the dark-brown back of an eagle on a ledge just ten meters below. In an instant he launches out into the updraught and is carried up and over my head, vanishing high into the sky behind me in seconds.

After clouds roll in for a while, a window in the mist down into Coire Amadal gives me a surprising glimpse of Uig and the west coast – like waking and seeing a foreign country from an aircraft. Soon afterwards the clouds which have capped Beinn Edra all morning waver, thin and disappear, and I climb up to the sharp little summit to take some food and rest. Far down below the ridge, painted cottages wink from the brown moors of east Trotternish, and white horses scud across the surface of a dark lochan. The mist around the hilltop comes and goes, but when it comes and doesn't go, I pack up and run down to the next bealach.

As I descend from Edra the cloud-cap dissipates

again, and I see that the ridge is now clear as far as the Quirang whose crags are the only ones still fog-bound. But the air is beginning to lose its clarity and I realise with a flash of irritation that that same old afternoon haze is building up again. The long descent to Bealach Uige is easy but wet underfoot, and at the bottom of the slope, small pools of clear water are cupped in soft grass and mosses.

This has been a long walk and the last climb of the day, up to Bioda Buidhe, seems unkindly steep and virtually endless; however, the summit does finally appear. Below, several detached buttresses and large stacs give a foretaste of the wonders to come tomorrow on the Quirang. A few hundred meters out from the cliff-edge the steep-sided little hill called Cleat ("cleit" – a rocky eminence) erupts from the tabular moorland with an importance quite out of proportion to its modest size. The houses of Staffin are directly below now, but seem far away as the first lights show in the dusk.

Only because the last kilometer is all downhill I reach the Quirang carpark still on my feet, after more than nine hours of non-stop walking; another hill, however small, would have had me crawling.

On the Quirang road

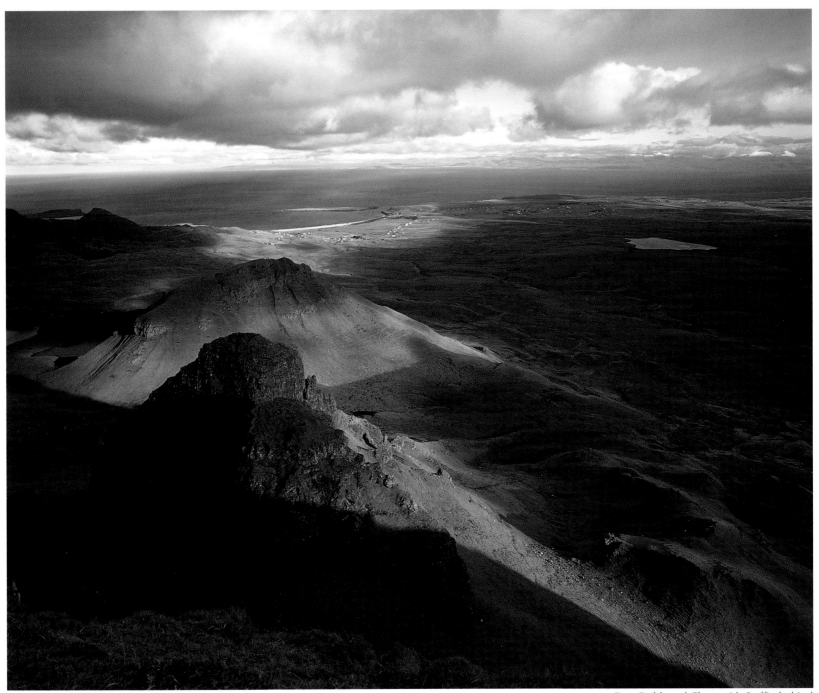

Dun Dubh and Cleat, with Staffin behind

Beinn Edra from Garros

DAY EIGHT, QUIRANG ROAD TO DUNTULM (9kms, easy day, height-gain 400m). A broad footpath leaves the roadside opposite the carpark, heading towards the cliffs of the Quirang. Follow this at first, then after 200m or so turn left and head up the open hillside, climbing high enough to reach a quite recognisable path which will take you above all the various lines of crags, climbing towards the spur called Maoladh Mor on the OS map. From here follow the clifftop east and north (dramatic views down through all the weird complexity of the Quirang and its pinnacles) and ascend to the summit of Meall an Suiramach. Descend northwards into the bealach below Sgurr Mor and re-ascend keeping near the cliffs on your right. From Sgurr Mor descend to the north-west, threading steep rocky slopes and short crags (no difficulties), then go across wide, open moors (wet) and the Kilmaluag River, to skirt past the westernmost houses of Connista village.

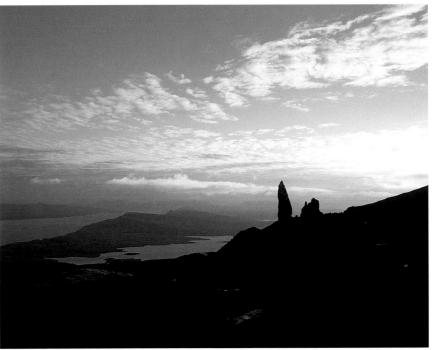
The Old Man of Storr

The miniature hill of Cnoc Roll may easily be avoided to east or west, but is best climbed for its stunning views out to the Minch and the Outer Hebrides. Duntulm lies directly below and Duntulm Castle Hotel has all the usual facilities.

Though the walk ends at Duntulm (at a place, rather than in the wilderness) it is worth the effort to go all the way to the northern-most tip of Skye at Rubha Hunish. The Western Isles line distant horizons, the rock, sky and ocean views are unparalleled, and the feeling of being at an end of the earth is irresistible. The round trip of six kilometers takes only about two hours plus the time you spend, gobsmacked, at the headland.

Last night I had the luxury of a tent, pitched in advance half-a-kilometer below the carpark and furnished with my warm sleeping-bag, good food and the makings of endless cups of tea, but today I have to pay the penalty with an extra climb back up to the pass before I can resume my walk. The sun comes up under a flush of bright-pink sky, painting the cliffs vermilion, but soon slides behind layers of soft grey cloud – a poor omen for today's weather. (In the Highlands, all portents of bad weather will be proved accurate; signs of good weather are mere wishful thinking.) Sure enough, as I make the steep climb up towards Maoladh Mor, a thin wetting rain begins to seep from lowering cloud. As this is only the second occasion in eight mainly dull days on which rain has actually fallen I have few grounds for complaint, but now there is that time-honoured choice to be made – between getting wet from rain or sweat – and I opt to put on waterproofs which at least creates the illusion of lightening one's load.

I am slipping and stumbling on wet grass and heather, hurrying too much when there is no need, being clumsy and losing my temper, after all, with the weather. As the path narrows to cross the head of a deep gully scoring the cliffs of Maoladh Mor another near-trip has me cursing myself aloud; I sense the absurdity of it all and stop to catch my breath, calm myself, and force a grin instead of a grimace. Afterwards I dawdle rather than march. Today's walk is a short one, and if the weather clears it would be better to be still up here on the tops than down on the northern moors before Duntulm. Soon enough the stacs and needles of the Quirang appear beneath me. The views from tourist path along the base of these cliffs, dramatic enough, bears no comparison to the preposterous array of rock-sculpture which is presented from the clifftop trail. One by one the famous features appear "The Prison", "The Needle", "The Table" but the overall impression is much greater than any sum of these individual parts. It is still raining, and wisps of cloud come and go among the pinnacles as I peer down through this collection of dragon's teeth which writhe up through the mist. Where the main cliff turns sharply north new miracles appear: a perfect series of grassy alps, each one raised on its own steep-sided table, lies in a deep depression below the cliffs. The far side of this sunken corrie is demarcated by a ridge of deeply-eroded black rock, notched and serrated like a dinosaur's back; the scene is one of dream or nightmare, depending only on your inclination.

I turn aside to visit Meall na Suiramach, the summit of the Quirang, and immediately my back is to the cliffs the scene-change is complete; a path leads off through a barely-rising tundra of compact heather and wispy yellowed grass to a horizon which, in this thin rain, could be a hundred meters away, or ten kilometers. In a few minutes, however, a low scatter of rocks appears, and the cairn which marks the summit. Through the northern mist the faint outline of another flattened dome is barely visible – Sgurr Mor, the Quirang's close compan-

ion, and the last mountain on my walk. Back at the corrie-edge I reclaim my pack and continue north, keeping to line of cliffs even when the path begins a steep descent; soon there are hazy views, under the cloud, of another two shapely peaks to the north, Sron Vourlinn and Leac nan Fionn, whose steep crags and jagged profiles would surely repay closer inspection. My route, however, approaches them only until a low rocky outcrop heading north-west shows me where to turn towards the eastern cliffs of Sgurr Mor, which I will follow, as I did the Quirang's, until immediately below the summit. For a short stretch I have the pleasure of level walking before there is a long easy pull up round the cliff-tops and then back to the top of the hill. A heavy cloud settles over Sgurr Mor as I climb, and now rain and floating mist obscure almost everything, though northwards there is an impression of vast space and emptiness, and glimpses under the cloud-base of a wide brown moor and the distant dots of cottages. As the cloud lowers still further, I quit the summit in dense mist and begin to make my way slowly to the west, using the cliff-edge as a guide until there is no more cliff, then feeling my way downwards, trying to be sure I am west of all outcrops, reading the rocks like Braille.

Quite suddenly, I am out from under and almost into sunshine; there are patches of pale blue sky, the undulating moor below is dappled with bright light, and the rain has changed from drizzle to iso-lated, heavy drops. At the base of the hill – lush meadows and ancient grassed-over walls – another

long-lost township, without doubt, and though I don't stop to look for the remains of cottages, they will be here, somewhere. Though it is a wild spot, this is no wilderness; groups of cattle and sheep graze the spring pasture, and new-looking fences topped with barbed-wire criss-cross the moor and make route-finding awkward, for there are no paths. Eventually I get on to the bank of a stream (curiously called the Lon Horro on the OS map) and follow it down towards the Kilmaluag River which I will have to cross, unsure of what to expect when I get there. Above a bend in the river, a tin shed and some shearing-pens sit in a green field; below, a fine wooden footbridge not marked on the map, and the last problem on my route is solved. The ground rises to the north of the stream, over a low ridge which conceals the hamlet of Connista, and I head up to the ridge and turn west along it, descending to the last of the houses. From its gate a track leads through a glen towards the southern slopes of Cnoc Roll, made obvious by the tall communications mast which rises from its sum-mit. Herds of rough-haired cattle graze here, too, and amble along the path ahead of me, moving aside only with great reluctance; gazing in mute reproach with their brown, sad eyes.

As I walk the weather continues its improve-ment. Behind me, the hills I crossed this morning are still wrapped in cloud but elsewhere the clouds are vanishing; by the time I have scrambled up Cnoc Roll there is only blue sky round every point of the compass except due south, and even the

wind has dropped, for the first time in over a week. There is still about a kilometer to walk to the ruins of Duntulm Castle, but this is really the end of my walk. The short grass on the hilltop is drying rapidly under a warm sun, and it is definitely time to sit for a while and enjoy the scenery, freed from the constant pressure to keep moving.

Below, long combers roll in from a dark blue sea along the shore of a curving bay. The Outer Isles bask on the distant horizon and the hills of Harris are deep-etched now in the rain-washed air, reminding me that I have walked and climbed there, too, in days gone bye. After half-an-hour, unused to all this leisure-time and feeling legs beginning to stiffen, I finally complete the walk with a gentle stroll down to the ruins at Duntulm.

Some months later, on a cyclonic autumn day, I finally make the trek out to Rubha Hunish. A gale lashes the island and violent rain-squalls come and go; bright sunshine rapidly paints the landscape, passing by in seconds, or sends stabbing searchlights down on the distant roiling sea. At the headland, the spray, the rain and the wind fuse into a single element with spellbinding power, and I stand mesmerised for long minutes before turning away and heading back towards Duntulm.

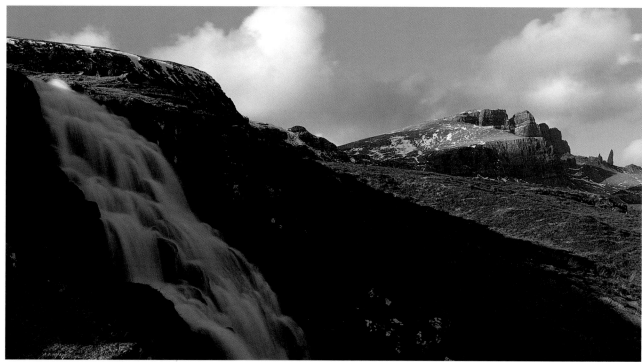

The Storr from the Staffin road

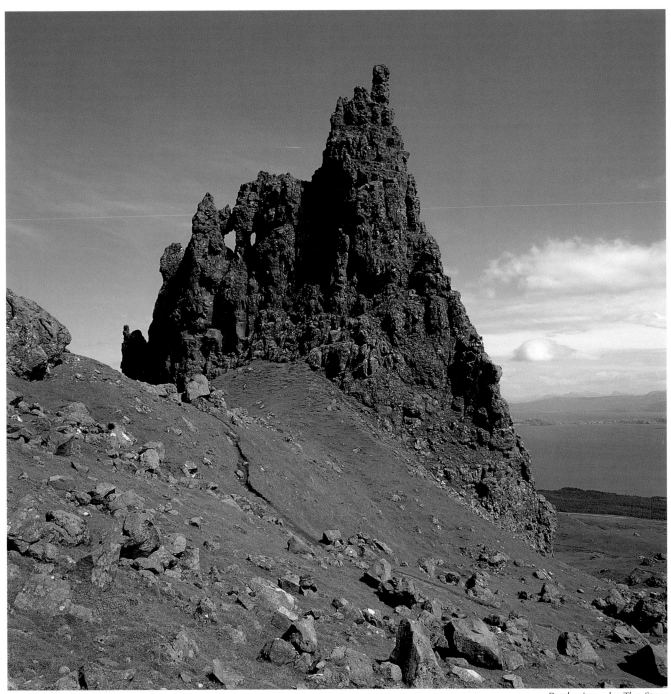

Rock pinnacle, The Storr

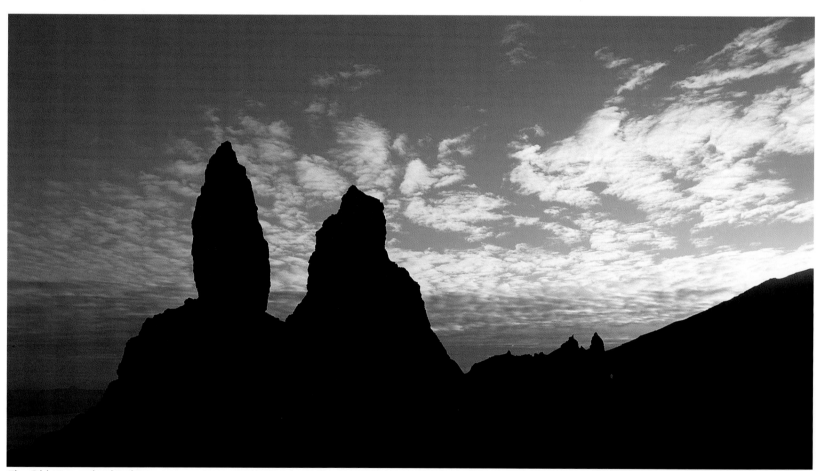

The Old Man and a daughter

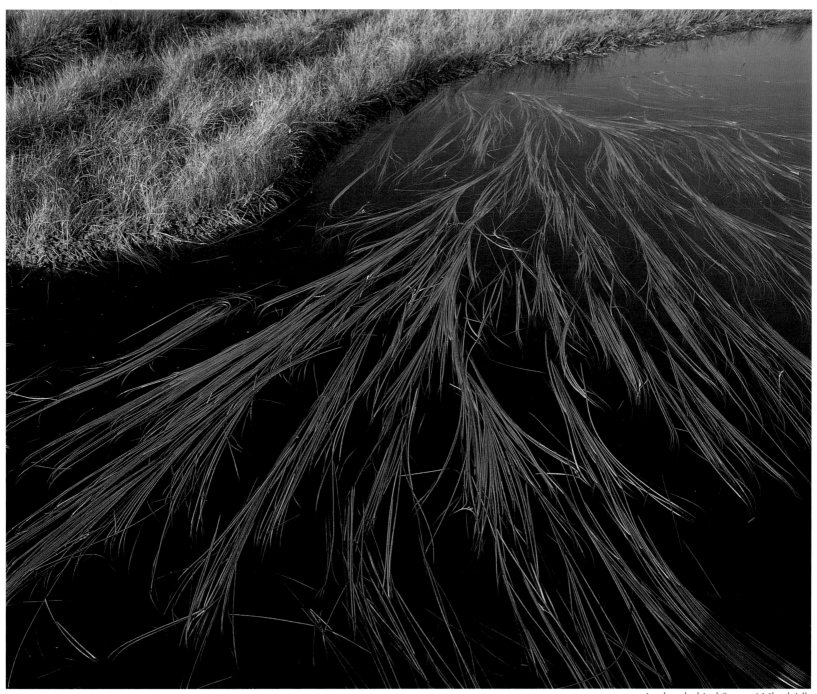

Lochan behind Sgurr a' Mhadaidh

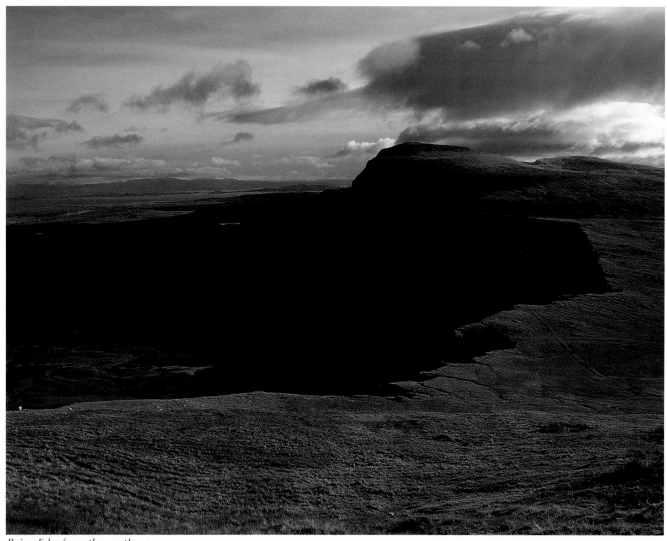

Beinn Edra from the north

L. Snizort and Macleod's Tables, from Groba nan Each

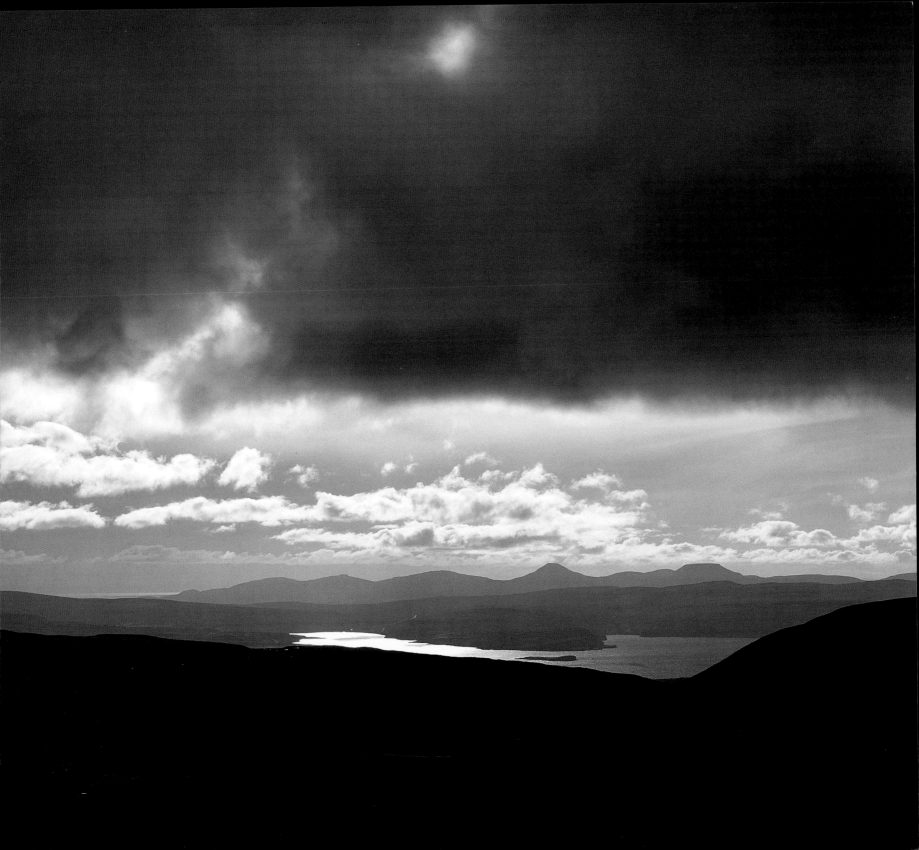

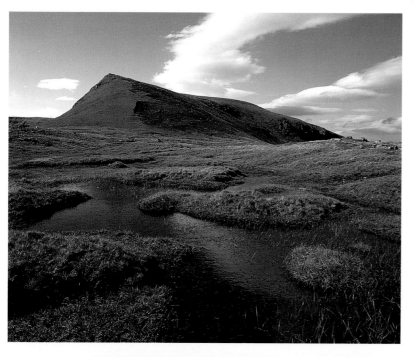
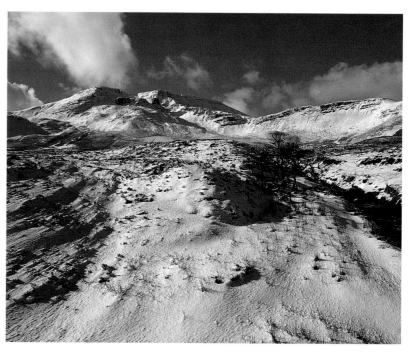
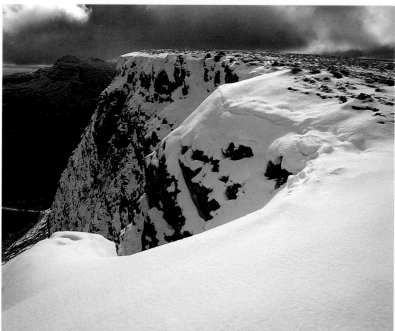
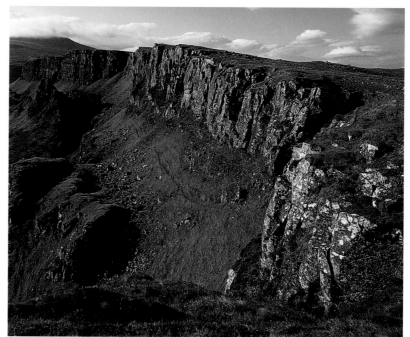

On the Trotternish ridge

Camp below Bioda Buidhe

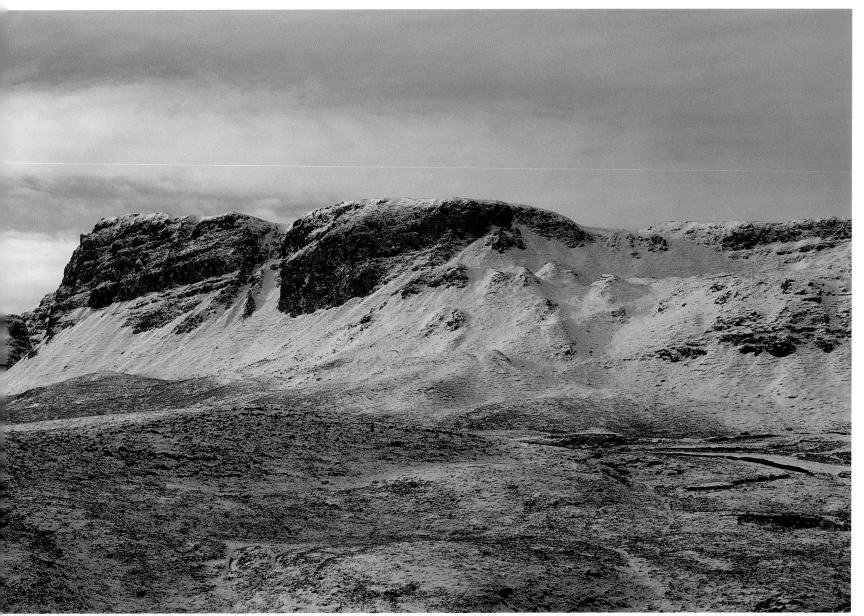

Cleat and Bioda Buidhe

Dawn over Dun Mor, from Maoladh Mor

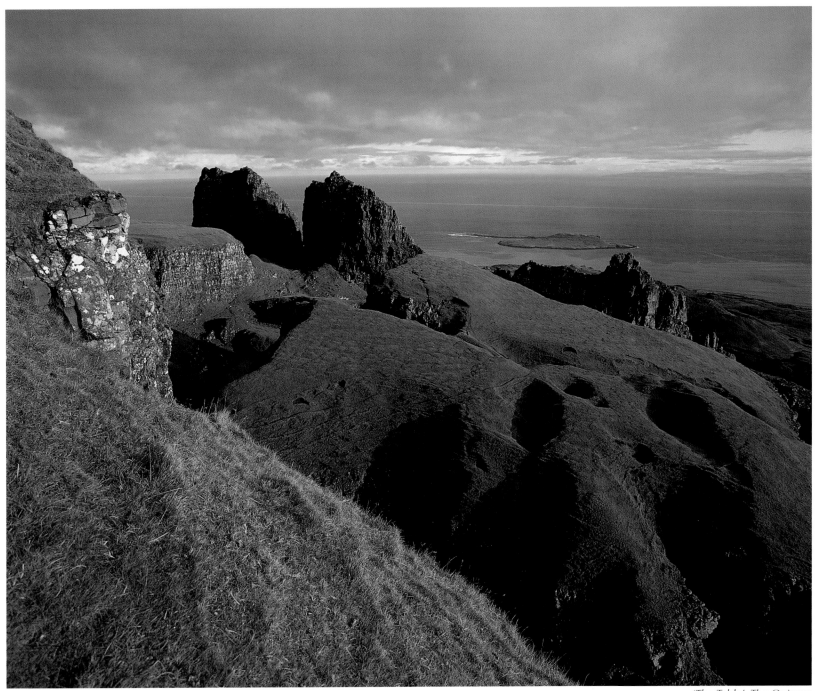

'The Table', The Quirang

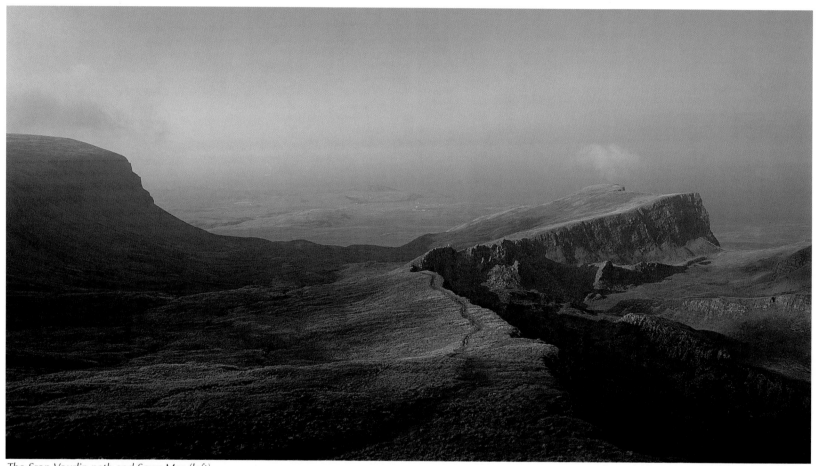

The Sron Vourlin path and Sgurr Mor (left)

Sgurr Mor from the north

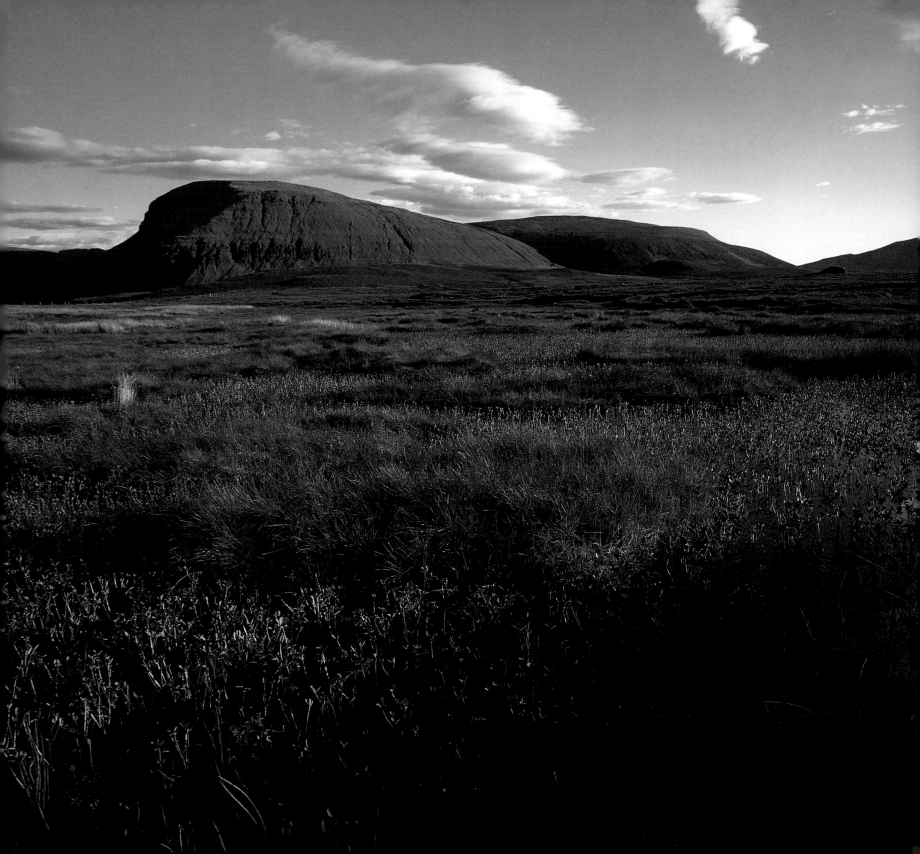

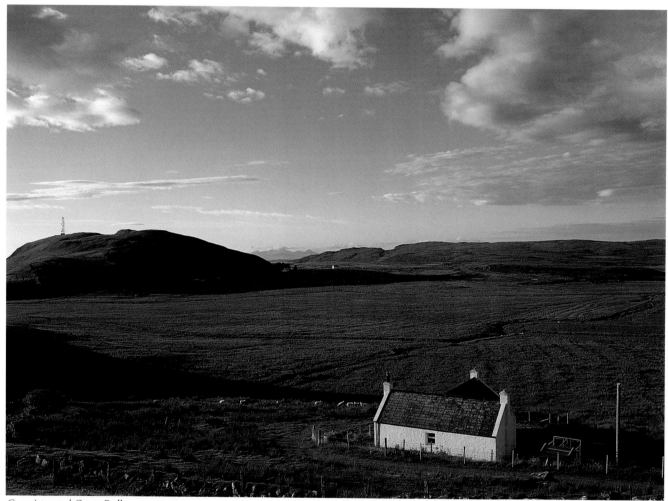

Connista and Cnoc Roll

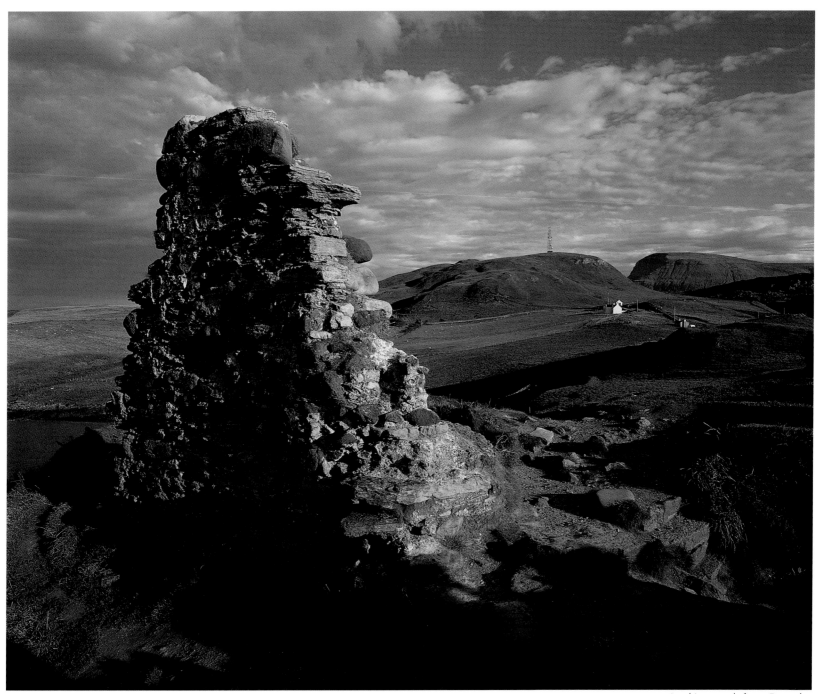

Looking south from Duntulm

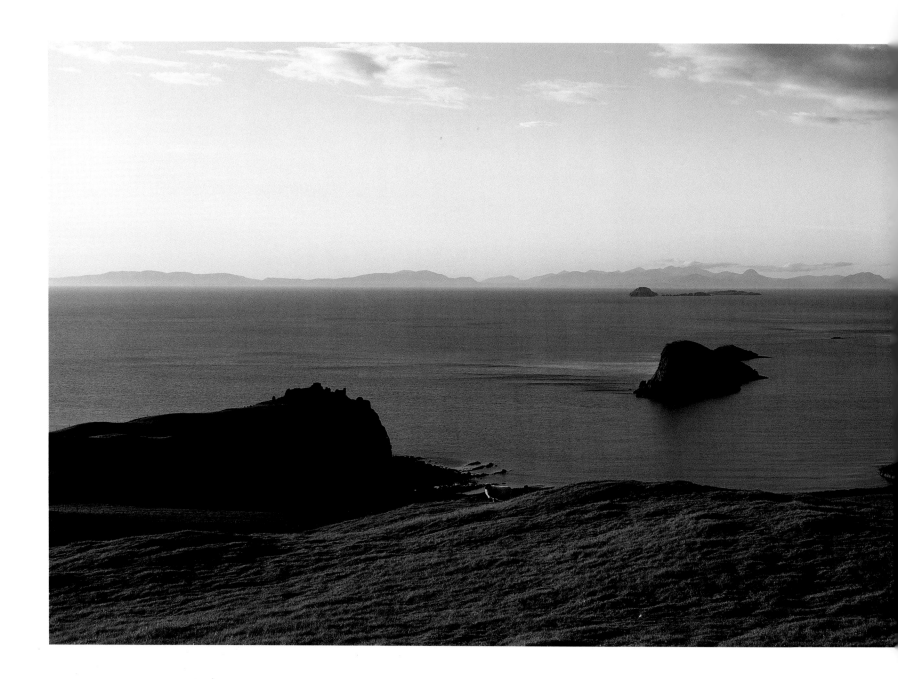

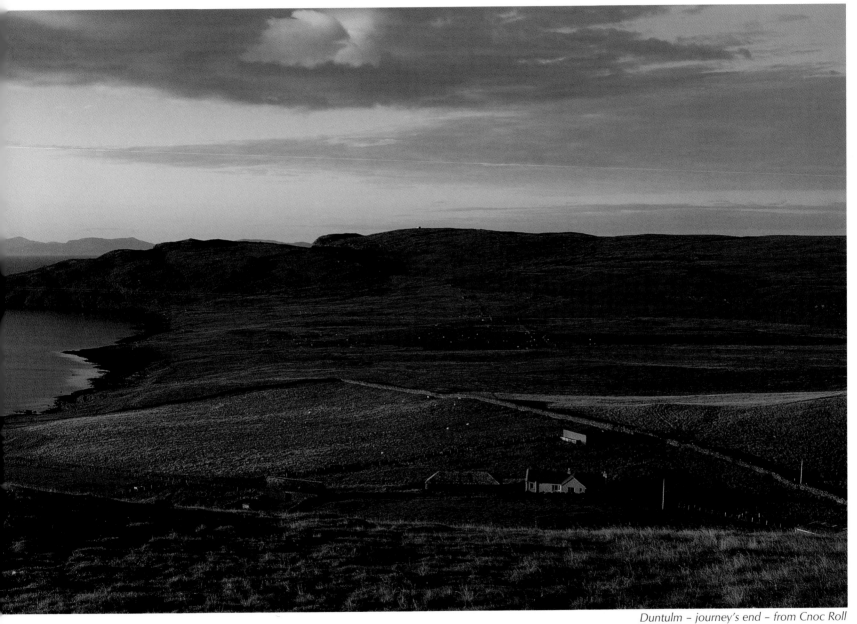

Duntulm – journey's end – from Cnoc Roll

Skye can be reached from the Scottish mainland at three places, two of which are of interest for the purposes of the walk. The more useful of these is the ferry from Mallaig to Armadale, since that is where the walk starts. Mallaig can be reached by bus or train from Fort William. The new bridge at Kyle of Lochalsh can also be used to reach Skye, though public transport from Kyleakin to Armadale is awkward. (Kyle of Lochalsh is also reachable by train or bus.)

Nightly accommodation is usually available along the route, though in the summer months it is wise to book in advance. At the end of days one, two, three, and six there is b&b to be had from May to September; on day four (Sligachan) there is a hotel open all year, and on day five (Portree) there is accommodation of all types. North of The Storr on days seven/eight, however, there is nothing until Duntulm. It is probably possible, just, to walk from The Storr carpark to Duntulm in one very long day but I wouldn't care to try it myself, carrying a heavy pack. I have walked to the Quirang road, about two thirds of the total distance, in some nine hours. The final third would be very demanding, and it might be better to split the total journey in half by bivouacking on or near Beinn Edra, though this could also raise problems. There is no shelter on the Trotternish Ridge, and it would be a terrible chore to carry bivouac gear all the way from Armadale but use it only once, on the last night of the walk. There are various remedies, one of which is to walk from The Storr to the Quirang road, hitch to Staffin where there is a wealth of b&b's, and take a local taxi back up to the pass the next day. Another possibility is mentioned in the main text.

Some parties will choose to camp all the way along the route, and in many respects this is the best solution. There is no longer a need to reach any particular point by nightfall, and camp can be made at any desirable spot along the trail (there are many). It should be remembered, however, that after the store in Ardvasar on day one, no shopping of any kind is possible until Sligachan, and then only chocolate, nuts etc. in the hotel bar. Real shopping is not available until Portree, on the fifth day on the route.

Though the route traverses some remote territory, it is very safe for a party of two or more trekking together. As long as no-one actually walks off a cliff, not only are there no technical difficulties, but in the event of accident or injury rescue is never very far away. Even at the farthest points of the wildest sections of the route the nearest road or village is never more than two hours' walk away. Along the way there are telephone boxes at Ardvasar, Tarskavaig, Torrin, Sligachan, Lower Ollach, Portree, and on the road one kilometer east of Duntulm Castle Hotel.

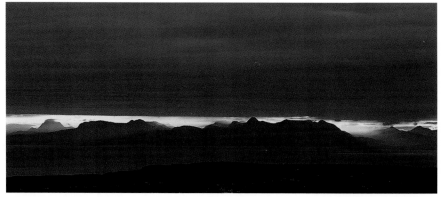

Dawn over the Western Highlands, from the Quirang

Weather information	0891.500.425
Caledonian MacBrayne (Mallaig)	01687.462403
Cal. MacBrayne (Armadale)	01471.844248
Tourist Information (Portree)	01478.612137
Tourist Information (Broadford)	01471.822361
Skye Coaches (Kyle of Lochalsh)	01599.534328
Highland Buses (Portree)	01478.612622
Sligachan Hotel	01478.650204
Staffin Taxis	01470.562716
Caledonian Taxis (Portree)	01478.612797
Ardvasar Taxis	01471.844361
Postbus Services Information	01463.256228